Architectural Acoustics

Architectural Acoustics

Christopher N. Brooks

McFarland & Company, Inc., Publishers
Jefferson, North Carolina, and London

Library of Congress Cataloguing-in-Publication Data

Brooks, Christopher N.
 Architectural acoustics / Christopher N. Brooks.
 p. cm.
 Includes bibliographical references and index.

 ISBN-13: 978-0-7864-1398-0
 softcover : 50# alkaline paper ∞

 1. Architectural acoustics. I. Title.
 NA2800.B76 2003
 729'.29 — dc21 2002014639

British Library cataloguing data are available

Cover photograph: Interior of the Holy Spirit Church in Lancaster,
Pennsylvania

Manufactured in the United States of America

McFarland & Company, Inc., Publishers
 Box 611, Jefferson, North Carolina 28640
 www.mcfarlandpub.com

To my wife, Lynn —
the love of my life

Table of Contents

To me, the greatest pleasure of writing is not what it's about, but the music the words make.

— Truman Capote

Preface

Architectural acoustics is often portrayed as some black art — a deep mystery penetrable only by the initiated. And there is something to this. Acoustics as a branch of physics involves heavy mathematics; and the practice of architectural acoustics involves knowledge of a broad range of subjects.

However, it is rarely the arcane physical theory that poses the greatest challenges to the practicing architectural acoustician, but rather the mundane conflicts among acoustical requirements, aesthetics and budget that go into designing a building. I hope to demonstrate in this book that the acoustics of spaces where we listen is determined by choices that people make when designing and building these spaces. These choices can be understood by the intelligent layman. I hope that this book will lead to better understanding, which will encourage better choices.

We have all been members of an audience, at one time or another. Not everyone has the opportunity to listen to concerts in Boston Symphony Hall, but nearly everyone has attended a church service, a lecture or a high school musical. One survey, for instance, showed that 100,700,000 Americans had attended a worship service within the past seven days.[1] Unfortunately, the vast majority of rooms in which we listen have poor acoustics.

I believe that this doesn't have to be the case. These rooms have poor acoustics because the people responsible for their construction are not aware that it could be otherwise. There was a time when people took stifling heat for granted at a concert or a church service, not realizing it could be otherwise. Nowadays, no one would dream of building any type of assembly place without perfect temperature control.

The existence of wonderful new concert halls — and there are some really wonderful new concert halls — demonstrates that we now know how

to create rooms with excellent acoustics. Few people realize that this possibility of acoustical excellence also applies to the other spaces where they listen. In fact, it is much easier to design a modest-sized assembly space –say, 650 seats— than it is to design a large concert hall that may have to seat over 2,000 people. So, why aren't there more excellent 650-seat rooms?

Rooms with excellent acoustics encourage focused listening. Audience members contribute to a concert, play, worship service or lecture with their participation. Audiences participate by sitting still and attentively listening to every sound created by the performer or speaker.

My goal in writing this book is to excite people about the idea, the possibility, of the experience of listening in a space that allows and encourages focused listening. I envision a day when every high school auditorium, church and lecture hall is a true critical listening space with excellent acoustics. The technical capability exists right now. I hope that when more people realize that it is possible and have the experience of listening in spaces with excellent acoustics, they will demand this experience in their local house of worship or school auditorium.

At times, I address architects directly since they actually design the spaces in which we listen, but I write for anyone who cares about listening. There are many excellent books on theoretical and architectural acoustics. I have included a short bibliography at the end of this book. I have also tried to be conscientious about citing sources in footnotes so that those who wish to pursue any of the subjects discussed will be able to go beyond what is intended as a series of personal reflections rather than a definitive scholarly text.

Since this is a book of personal reflections, I have included discussion of subjects that are related to, but not strictly included in the category of architectural acoustics. Environmental noise, for instance, is important because buildings for listening sit in an environment; and not all of our listening is indoors. I have also included some discussion of the subjects of music, dialogue and intonation. One has to listen to something. The poetry under chapter heads is a hint. Poetry is to be listened to, not merely read silently.

I have a dream. With a little forethought and a little care, we could have a landscape dotted with acoustically superb, modest-sized performance spaces and houses of worship. I use the same design philosophy whether working on a world-class performing arts center or a high school auditorium (though the budgets may differ). After all, the local high school auditorium is often the regional performing arts center. I want to excite others with my vision, because I can't possibly do it alone. The only way to fulfill this dream is through clients who pay for the design and construction of these potentially wonderful buildings.

I would like to thank Russell Johnson for giving me the opportunity to work on some world-class projects and whose comments on several chapters were tremendously helpful; David Greenberg, from whom I learned much of what I know about architectural acoustics; James Mitchell for his continuous encouragement; Peter Svennson and Michael Barron who provided valuable criticism on acoustical modeling; Robert Long who tightened up my thinking on performance spaces; Peter Frink who gave me my first job in the field; Wanda Loskot who pushed me into writing this; and my wife Lynn and son Ethan for being my family.

— Christopher Brooks

Introduction

Music, when soft voices die,
Vibrates in the memory.
— Percy Bysshe Shelley

What Do I Listen For?

Since I am encouraging people to listen more attentively, it is fair to ask how I myself listen. First, I must admit a certain tension between listening as an acoustician and listening as a lover of music (especially when the acoustics are less than ideal.) When listening as a lover of music, I listen for the story being told by the performer in the precise emotional language of music. I want to follow that story in every detail, as closely as I can. I don't want to miss a note, a nuance, a moment of silence. Acoustics (and audiences) can allow and support this—or can interfere.

I listen for the soft sounds. I love to hear quiet passages in chamber music, or the sound of a single piano note as it fades into nothing, or the reverberant afterglow when the players pause. This is why I dislike when people applaud immediately after the final chord of a piece. I want to hear the music framed by silence. I find that listening to the quietest sounds puts my mind into a centered place that allows me to focus in and adhere to the musical story. This is one reason why I consider the absence of background noise in performance spaces to be so fundamentally important (more on this later).

In full passages, I love to be wrapped up in the music. A great hall can provide this experience. I remember listening to a concert with organ and orchestra in the Eugene McDermott Concert Hall in Dallas, Texas. I was completely surrounded in every direction—up, down, front, and back—by music.

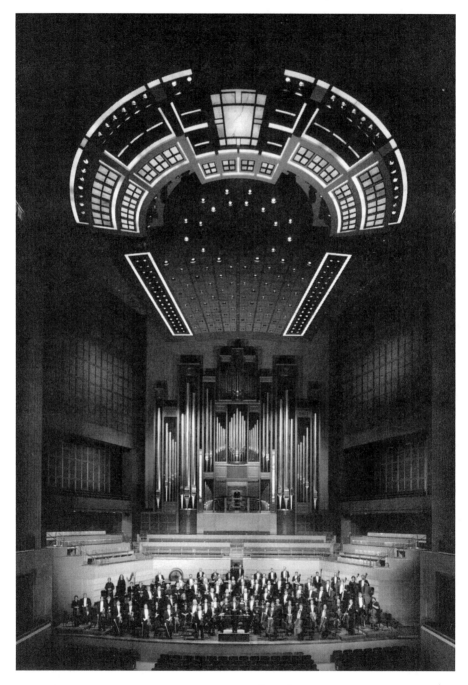

Figure 1. Eugene McDermott Concert Hall, Dallas, Texas (©Gittings, 2000).

Some halls enhance and support a performer's tone. I once heard a small chamber ensemble in the Troy Savings Bank Music Hall in Troy, New York. This small ensemble had a single 'cello and one bass, yet it completely filled the hall with warm bass sound — like chocolate. The acoustics of the Troy Savings Bank Music Hall can be heard on the CD by Dorian Recordings® *The English Lute Song.*[1] In fact, Dorian Recordings Co. is located in Troy, New York, in order to take advantage of the rich acoustics of the Troy Savings Bank Hall.

One indication of the sound quality of a hall is the sound of the audience murmuring before the concert. In Carnegie Hall in New York City, this sounds like a light rain falling in a dry forest — a lovely foretaste of the aural treats to come.

Most listeners (who are not acousticians) are not consciously aware of the acoustics of the room in which they are listening. This is probably a good thing. Acoustics ought to be transparent, supportive of the performer, rather than being the main event. One aspect of acoustics of which people may be consciously aware is reverberation: the persistence of sound in a room after the source has ceased. It can be heard by clapping one's hands and listening to the sound die away. As a general rule, I like reverberation, as long as it complements rather than overwhelms what I am listening to.

There is no strict correlation between reverberation and acoustical quality; certain types of music are happier in reverberant acoustics than are others. A choir in cathedral reverberation can be ravishing; an orchestra would be overwhelmed in mud. For a reverberant room to have any hope of clarity, however, background noise must be absent, and the geometry must be correct.

I also get a great deal of pleasure from hearing people speak in a good room (without amplification). I get a particularly clear concept of a room's acoustics from hearing speech, perhaps because speech is so basic to human hearing. The opportunity, however, is increasingly rare. Here I am in a world-famous concert hall. The acoustics are, well, world famous. Supposedly one can hear every nuance, the most complex counterpoint, the proverbial pin drop; I can even hear the rests. Someone gets up to say a few words— and brays at the audience through an overpowered sound system. It is unnatural, it is ugly, and it discourages careful listening. Loud amplified speech says "DON'T BOTHER TO REALLY LISTEN; WE'LL SCREAM AT YOU!" Occasionally, one gets to hear a performer say a few words impromptu from the stage, unmiked. I like that.

In many rooms, unfortunately, the acoustics are mediocre, or worse. In such situations, I try to focus on the music and avoid being distracted

by the poor acoustics. When the acoustics are great and the music is great, I find myself magnetically attracted into the compelling story of the music. The more I listen, the better it gets.

The opportunity for this experience is rare; I would like it to be more common.

1. What Is Classical Music?

Sweet sounds, oh, beautiful music, do not cease!
Reject me not into the world again.
With you alone is excellence and peace,
Mankind made plausible, his purpose plain.
Enchanted in your air benign and shrewd,
With limbs a-sprawl and empty faces pale,
The spiteful and the stingy and the rude
Sleep like the scullions in the fairy-tale.
This moment is the best the world can give:
The tranquil blossom on the tortured stem.
Reject me not, sweet sounds; oh, let me live,
Till Doom espy my towers and scatter them,
A city spell-bound under the aging sun.
Music my rampart, and my only one.
— Edna St. Vincent Millay,
On Hearing a Symphony of Beethoven

Most (though not all) of the music that I listen to is classical music. The term "classical music" is used to denote a particular musical tradition; perhaps more accurately named "Western Art Music." The word "classical" implies music that rewards repeated listening. What then is classical music?

Is It Music by Dead Guys?

No. There are some excellent classical music composers living and composing right at this very moment: David Diamond, Steve Reich, Phillip Glass, Michael Torke, Joseph Schwantner, Aaron Jay Kernis come to mind; and I have chosen these names only from among American composers. There are many others. One of the best sources I know for the names of important living composers is the Lancaster Symphony Orchestra Composer's award, awarded yearly by the Lancaster Symphony of Lancaster, Pennsyl-

vania. I don't say this merely because I used to play in this orchestra. This award is given each year to the composer who the committee believes is the most important American composer at the time. It was first given to Howard Hanson in 1953, and the list of award winners includes just about every important contemporary American composer. We are too close in time to the works of these composers to say which are destined for the ages. Nevertheless, the tradition does continue.

I recommend David Diamond's accessible, directly emotional yet complex orchestral works, recorded by Gerald Schwartz with the Seattle Symphony and the New York Chamber Symphony on Delos. Symphony No. 4 (1945)[1] demonstrates Diamond's complete mastery of the orchestra. The piece sounds like a short section of a work that actually goes on forever. It is short, emotionally direct, but well crafted, and romantic without being cloying. Diamond's *Music for Shakespeare's "Romeo and Juliet"* (1947)[2] contains a simple and affecting balcony scene with Romeo and Juliet portrayed by solo viola and violin. I find myself repeatedly returning to Diamond's music, which bears out my definition of the word "classical."

Is It Only Music from Germany?

No. The classical music tradition first flourished in Italy, then France. The Germans (and Austrians) dominated in the 19th century, but since then the tradition has spread all over the world from Eastern Europe (Dvorak, Smetana, Janecek) to Spain (Granados, Falla) to the Scandinavian countries (Grieg, Sibelius) to Japan (Takamitsu) to San Francisco (Lou Harrison) to Argentina (Piazollo). The last truly great German composer was Paul Hindemith, and he spent many years composing in the United States, teaching at Yale.

Perhaps It Is Just the *Best* Music?

Perhaps. However there is bad classical music (Meyerbeer, Offenbach) and some excellent music that is not classical (Miles Davis,[3] the Childe Ballads[4]). Similarly, there are some very beautiful buildings that are not designed by architects: Just look down the streets of any old, Mediterranean city. What architect has been able to surpass the charms of the hill towns of Greece or the white-walled streets of Cordoba?

Classical music is part of a particular tradition — a very long tradition, and one that has always been open to influence from the world over: folk music, music from other continents (especially from Asia), and (in the twentieth century) jazz. The fruitful interaction between classical music

and jazz goes both ways and would be a suitable topic for a large book. It is said that the great jazz saxophonist Charlie Parker walked around with a copy of the score of Stravinsky's *Sacre du Printemps* in his pocket. Stravinsky returned the favor with jazz-based works such as "Ragtime." The great Tin Pan Alley songwriter, George Gershwin studied composition with Ravel, who is reported to have said that given their disparity in incomes, he ought to study with Gershwin. Both the great jazz pianist Bill Evans and certainly the most listened-to jazz performer, the supreme Miles Davis, were both classically trained. The classical composers Leonard Bernstein and Lucas Foss (among many, many others) successfully incorporated elements of jazz into their work.

What distinguishes the classical music tradition is the way the music is created. Like architecture, music is first written on paper (nowadays increasingly on computer). It is silent — heard only by the composer in his mind. Musicians must create sounds from these mute scribblings — rarely getting any other information from the composer. It is only at the performance that the music truly comes to life through attentive, active listening.

Because classical music is reconstituted from print, the musician has the marvelous opportunity to collaborate with some of the deepest minds in history. This afternoon, I collaborated with J.S. Bach on his first sonata for unaccompanied violin. He wrote it; I play it according to his instructions.

This approach allows the performer room for interpretation. A score no more completely defines a piece of music than a set of drawings and specifications defines a building. There is ample room for the artful interpreter to shine. This collaborative effort is one reason that classical music is so essential for the education of children. When a child sits down at the piano to play a sonata by Mozart, it is as if the great man stopped by for a visit.

Intonation, Tuning and Temperaments

Intonation is a primary concern for all musicians — especially string players. Due to my own long struggle with the problem, I became interested in a more scientific approach. In fact this was my very first work in acoustics, before becoming involved in architectural acoustics. Oddly enough, in all my years as a serious student of classical music and the violin — including conservatory training — I was never exposed to the basic theory of intonation, though I studied music theory and composition extensively.

Pure Tones

The sounds of most instruments are fairly complex, with constantly changing amplitude and spectrum. However, for the sake of this discussion,

we can think of these sounds as a series of superimposed pure tones. When we look at a pure tone on a graph of time versus sound pressure, we get a sine (or cosine) function. For this reason, pure tones are called sine waves. See the left hand side of Figure 3. (The top part of Figure 3 is the same as the lower part at a larger scale.)

The frequency of a pure tone is how often the sine pattern repeats per unit of time. The unit for frequency is cycles per second, now called the Hertz. We perceive the frequency of a tone as its pitch.

Beats

When two sine waves with slightly different frequencies are played simultaneously, they interfere and create a composite wave that pulses at the rate of the difference between the two frequencies.

Figure 3 starts out on the left side with a pure, steady, 440 Hz (440 cycles per second) sine tone. An additional pure tone sine wave at 448 Hz is introduced roughly half-way through the illustration; these two tones intefere to create a combined sound that beats at 8 cycles per second — the difference between the two frequencies.

Beats are what make out-of-tune intervals sound rough. They are easiest to hear with pure tones near unison, as I have demonstrated, but they are also present in more complicated intervals. Beats are used to precisely tune pianos to intervals that are precisely and consistently out of tune. More on why this is necessary below.

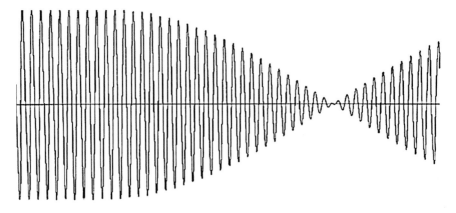

Figure 3. Pure sine wave and beats.

Overtones

Musical instruments produce sounds comprising many pure tones superimposed, called overtones. In musical tones, the frequencies of the overtones are in whole number ratios to the lowest tone, called the fundamental. So, for instance, the middle C on the piano has a fundamental frequency of 523 Hertz. An ideal piano string would contain overtones of 1046 Hz., 1569 Hz, 2092 Hz, etc. Real-life piano strings are stiff, and so their overtones are not exactly whole-number ratios with the fundamental. This turns out to be a good thing. The pitch of the fundamental is heard as the pitch of the complex musical tone. The overtones with whole-number frequency relationships are called the harmonic series, and are the physical basis of musical intervals, harmony, and intonation.

Intervals and Their Numerical Relationships

A musical tone with its harmonic series is illustrated by each of the "ladders" in Figure 4. Each "rung" is a harmonic overtone, labeled by its frequency relationship with the fundamental. In the illustration, I use the logarithm of the distance on the page to represent frequency, because we hear pitch logarithmically. The overtones weaken as they go higher, but the series continues infinitely (at least in theory). only shows the first 16 overtones.

Figure 4 illustrates pairs of musical notes at the consonant intervals, in order of descending consonance (ascending dissonance). The consonant intervals are those that sound together, hence the name. When two musical tones sound together at a consonant interval, some of their overtones match up. This is illustrated by connecting the rungs of the ladders. The most consonant interval (after the unison) is the octave. As you can see, every other overtone of the lower member of an octave pair matches with every overtone of the note an octave above. Intervals with fewer, and higher matching overtones are less consonant. Intervals that are more consonant blend more when they are in tune, but sound worse when they are out of tune. It is very critical to tune octaves or fifths precisely, but thirds and sixths are routinely altered by substantial amounts.

It is believed that Pythagoras (C. 570–500 b.c.) discovered the whole number intervals for the octave, fifth and fourth, called the perfect consonants. The ratios for the imperfect consonants (thirds and sixths) were discovered by the Italian theorist and composer Gioseffo Zarlino (1517–1590).

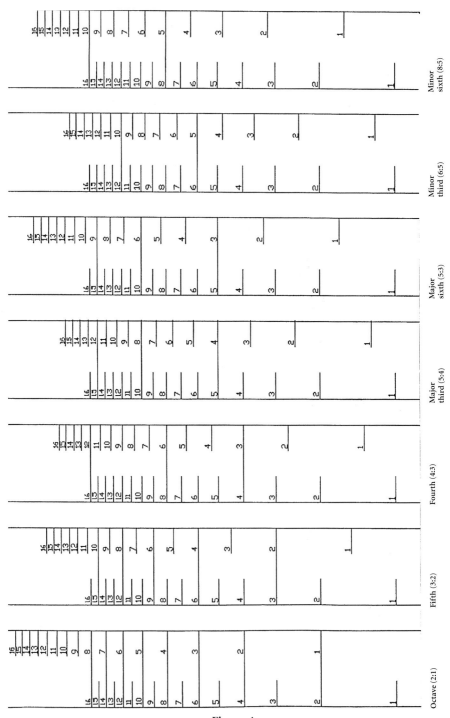

Figure 4

Table 1
Consonant Intervals

name	Octave	Fifth	Fourth	Major third	Major sixth	Minor third	Minor sixth
frequency ratio	2:1	3:2	4:3	5:4	5:3	6:5	8:5

Why Intonation Is Impossible

Because of the unique prime factor theorem, it is mathematically impossible to play consistently in tune. The unique prime factor theorem states that any integer is the product of a unique set of primes. This means that you cannot reach the same note from a starting note by means of different consonant intervals, unless one interval is a multiple of the other (for example the fifth [3/2] fourth [4/3]).

If you tune the open strings of the guitar to pure, beatless fourths (E, A, D, B), and a major third from G to B, tuning a pure fourth from B to the top open E, will produce an E that is flat relative to the bottom E. This is why guitarists often tune by frets, and why the good ones tune differently for different keys, or stretch the fourths.

Here is an example that is easily audible on violin, viola or 'cello. Tune the open A (440 Hz), D (293.3 Hz), and G (195.6 Hz) open strings by beatless perfect fifths. Then play a pure E (326 Hz), first finger on the E string, a major sixth above the open G. Make sure there are no beats. It will be lower than you think. Against the open A (440 Hz) this E will be very flat, because a perfect forth below A (440 Hz) is 330 Hz. The difference of 4 Hz is quite audible. (See Table 2, below.)

Table 2

note name	frequency interval	frequency ratio
A	440 fourth down	3/4
E	330	
A	440.0 fifth down	2/3
D	293.3 fifth down	2/4
G	195.6 major sixth up	5/3
E	325.9	
Difference	4.1	

This means that when playing the E on the D string as part of a C major chord containing an open G, one must play distinctly lower than when playing an A major chord with open A and open E strings. Few string players are aware of these discrepancies, which is why so few string players

play in tune. The attempt to mask the confusion with heavy vibrato only compounds the difficulty.

Real Life

What does this mean in practice? For fixed-note instruments such as the piano or organ a method has to be found for traveling from one note to the next regardless of the intervening intervals. The organ poses the thorniest problem because its sustained, pure tone makes intonation painfully apparent. Many schemes, called temperaments, for tuning the organ and other keyboard instruments have been tried over the centuries. The major drawback to most of these schemes is the fact that they tend to favor some keys over others.

Perhaps the most successful (though far from perfect) scheme is equal temperament, in which the octave is divided into 12 equal ½ steps. This is the standard method of tunings for most keyboard instruments, though there are some organs that are tuned in some of the many older temperaments. Harpsichordists will sometimes use other temperaments to suit particular pieces. Since you have to tune a harpsichord constantly, this is a wonderful opportunity to hear the differences in tone provided by the various temperaments.

In equal temperament, all intervals are distorted. Fourths and fifths are not so bad, but major thirds and sixths are too wide and minor thirds and sixths too narrow. Equal temperament really took off with the piano because the piano with its decaying tone and stiff, inharmonious strings hides the defects of equal temperament pretty well. The stiff strings and the behavior of our ears require that octaves, too, be distorted by stretching. The piano is tuned sharper at the top, and flatter at the bottom, in order to sound in tune.

With other instruments, the player controls pitch while playing. Wind instruments are tuned based on equal temperament, but the player can adjust to match the intonation of other instruments. Because of their pure overtones (columns of air are not very stiff), and sparse use of vibrato, woodwind and brass groups can play very purely in tune. For the same reasons, they sound particularly sour when even the slightest bit *out* of tune.

String instruments are notoriously difficult to play in tune because the player has to stop the string with his fingers, rather than pushing a key or stopping a hole. This can become particularly precarious in the higher positions and while shifting between positions on the fingerboard. The open strings are the standard against which string players tune and these

stretch out of tune as they are played. Fortunately, modern strings made of synthetic materials are much more stable than the old strings made of sheep's intestines (not catgut).

Two other factors exacerbate the difficulty of playing string instruments in tune. One is the tradition of playing with exaggerated leading tones, sometimes called "expressive intonation." The other is excessive use of vibrato.

Following the practice of expressive intonation, the major third and major seventh of a scale are raised to lead to the next higher note. These notes are called "leading tones" because they lead melodically to the next higher note. For example, an F# in the key of G major is raised before a G to lead to it. This can work pretty well when the F# is not a member of a chord, or when playing with piano which tends to have higher 3rds, and tends to mask intonation somewhat. Expressive intonation can also work well for a soloist, because it tends to raise pitch overall and make the soloist stand out above the orchestra. The master of this approach was the great Jascha Heifetz. His tone was like a razor, cutting through and floating above an entire orchestra. He was also absolutely consistent in his intonation.

The drawback to expressive intonation can be heard on Heifetz's recordings of the Bach solo sonatas, which are excruciatingly harsh because of the exaggerated intervals.

Vibrato is the practice of rocking the finger, which modulates the pitch of a note around the note, imitating the vibrato of a relaxed singing voice. Vibrato is a powerful expressive tool, and an intrinsic part of the sound of the string instruments, and some winds. However, when it is used indiscriminately and too early in the study of an instrument, it can seriously undermine a student's ability to hear and play in tune.

Both vibrato and raised leading tones are expressive effects that have their legitimate uses. However, these practices should be built on a solid foundation of understanding of the theory and practice of pure intonation. More widespread teaching of this fundamentally important and fascinating theory would improve the playing of musicians everywhere.

2. What Is Acoustics?

Listen! You hear the grating roar
Of pebbles which the waves draw back, and fling,
At their return, up the high strand,
Begin, and cease, and then again begin,
With tremulous cadence slow, and bring
The eternal note of sadness in.
~Matthew Arnold, *Dover Beach*

Hearing in Rooms

In this section, I discuss room acoustics from the perspective of human hearing. Both hearing and room acoustics are enormous subjects, and I make no attempt in this book to be thorough or technical. Rather, my intent is to sketch out some of the basic concepts that underlie my own practice. Anyone who wishes to delve deeper may visit the short bibliography at the end of this book.

Acoustics is widely misunderstood because our hearing system is designed to discount acoustics. When you speak, I hear what you are saying, coming from where you are sitting — rather than the myriad sound reflections of your voice that bounce all around the room. Our hearing is able to place noise in the background; we don't notice it, even though it is theoretically audible. We can consciously bring noise into the foreground, if we wish, but ordinarily, we are blessedly unaware. If we were aware of all the sounds around us, the noise, the reflections — we would go mad.

From the point of view of a listener, the acoustics of a room result from the following elements: direct sound, reflected sound, and noise, as illustrated in the sketch below.

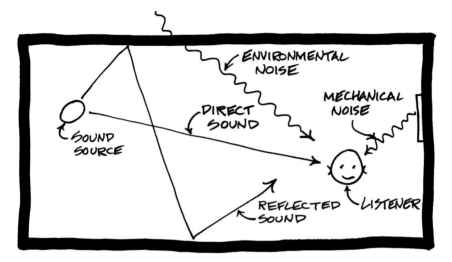

Figure 5

Direct Sound

Imagine you are in a room listening to a sound source (say, a violin). Sound radiates out of the violin in all directions, traveling at roughly 1 foot per millisecond (roughly 1130 ft. per sec. at room temperature). If you are sitting 30 feet from the violinist, the sound will reach your ears 38 milliseconds after he moves his bow, the sound traveling in a straight line from the source. This is the direct sound, which is all that you would hear if there were no nearby surfaces to reflect sound. The only way to affect the direct sound is to vary distance from the source. Farther, the sound is less intense; closer, the sound is more intense: the same amount of sound energy is spread thinner as it radiates from the source.

If you move very far away from the source, you will begin to hear that some of the sound is absorbed in the intervening air. Air absorbs high frequencies more effectively than low frequencies. This is best illustrated by thunder. Nearby thunder "cracks," while distant thunder "booms." The difference between "crack" and "boom" is the high-frequency sound that is absorbed as the sound travels farther through the air. Air absorption is not a practical concern in smaller rooms, but it is quite audible in larger rooms such as arenas or cathedrals.

Sound Reflections

After the direct sound arrives at your ear, sound also arrives after having reflected off the surfaces of the room. We don't hear these reflections

as separate events. Rather, we hear the sound as coming from the direction of the direct sound; we hear the reflections as reinforcement or enhancement of the direct sound.

EARLY SOUND REFLECTIONS

Sound reflections that arrive soon enough after the direct sound will be combined with the direct sound by the ear and brain. These are called "early sound reflections." These early reflections are not heard as separate reflections but rather reinforce the perception of the direct sound. They affect our perception of the quality of sound and our spatial perception of sound. In modest-sized rooms, the early sound reflections from nearby walls, ceiling, and furniture reinforce the direct sound and make it relatively easy to hold a conversation. It can be surprisingly difficult to converse at a distance outdoors in an open field because of the lack of these nearby sound-reflecting surfaces.

LATE SOUND REFLECTIONS

We don't hear early sound reflections discretely but rather as enhancements (or distortions) of the direct sound. Later sound reflections, on the other hand, are heard as sound persisting in the room. This difference is not due to any abrupt change in the nature of the sound itself as it blithely bounces about the room. Rather, our hearing system processes sound reflections differently depending on their temporal relation to the direct sound. The relationship between early sound reflections (including direct sound) and late sound reflections can be measured in existing rooms and calculated in models. It gives us very useful information about how sound will be perceived in the room, in particular how well speech will be understood.

Reverberation

The audible persistence of sound in a room is called "reverberation." The rate at which this persisting sound decays is called the "reverberation time." A room where later sound reflections persist for a long time is called "reverberant" or "live"; a room where the sound dies out quickly is non-reverberant or "dead." The behavior of sound in a room is determined by the shape of the room and by the nature of the materials out of which it is constructed. Rooms with a lot of sound-absorbing material will tend to be less reverberant. In assembly spaces, such as churches or auditoriums, the most important sound-absorbing material is usually the audience (or congregation). Since the audience is usually on the bottom of the room, rooms with high ceilings tend to be more reverberant. This is why concert-hall

ceilings are much higher than they would need to be for merely housing an audience. The volume above the audience is important for developing reverberation.

Listeners are rarely aware of reverberation; rather, they are aware of how reverberation enhances (or interferes with) what they are listening to.

ECHO AND REVERBERATION

People often confuse the terms "echo" and "reverberation." The two are related but not exactly the same. An *echo* is when you can hear distinct sound reflections coming back to you: "HELLO ... Hello ... hello ... lo ... lo ... lo. The clearest echoes are outdoors where there is essentially no reverberation.

Reverberation occurs when sound in a room continues reflecting off the boundaries of a room. The original sound and the repeated reflections blend together into a single, longer sound. One rarely hears an echo in a highly reverberant room because strong later reflections that might have been echoes are covered by other sound reflections.

Reverberation is inherently neither good nor bad. Its desirability depends on the room's function. Reverberation reinforces sound, which is why (generally speaking) it is good in a concert hall, bad in a cafeteria. Echoes are nearly always bad in a performance space. An interesting exception to this general rule is the fact that a barely audible echo can be desirable for singers, because they need feedback from the room to properly gauge their singing.[1]

Reverberation reinforces all sound in a room, including background noise. In fact, reverberation itself is usually not perceived directly by the ordinary listener but rather its interaction with what the listener is trying to hear — adding a glow and a sense of envelopment to music or interfering with speech.

The persistence of reverberation is measured by reverberation time: the time it takes for sound in a room to decay by 60 decibels. A concert hall may have a reverberation time in the 2-second range. Less than 1 second is considered good for speech. The tone color of a room is also affected by reverberation. A room with longer reverberation in the lower frequencies may be perceived as warm, or if too much, "boomy." A room with too much high frequency reverberation might be perceived as "harsh" or "glassy" in tone, though there may be other reasons for these perceptions.

The music-listening population seems to be divided roughly in half concerning reverberation. Some do not like reverberation; they want their music clear and clean. Others (myself included) love to hear music in a rich, reverberant space. I know of no explanation for this interesting

dichotomy, and I know of no research on the topic. Here is a good subject for a psychology dissertation.

Noise

In addition to direct sound and sound reflections, there is noise in every room. Minimal background noise levels are essential to good acoustics for listening spaces. On the other hand, a certain level of noise is essential in offices and other public spaces to mask the distraction of other people's conversations and to aid privacy.[2]

Noise plays a fundamentally important role in acoustics for listening, but it receives surprisingly little attention in the public mind or even in the literature. Our miraculous hearing systems are designed to seek out the signal (that which we are paying attention to) and to filter out noise. For this reason, people are rarely aware of noise. For normal life, this is a good thing. However for excellent acoustical design, we must become exquisitely sensitive to noise.

Silence Is Golden

Let us be silent that we may hear the whispers of the Gods.
~ Ralph Waldo Emerson

Silence and background noise

Like a blank canvas for a painting or a clean plate for a gourmet meal, silence is the *sine qua non* of good acoustics. But what is silence? Silence is the absence of noise, and noise is unwanted sound. During a lecture or sermon, any audible sound not made by the speaker is noise; during a performance, any audible sound not created by a performer is noise.

There are, of course, many aspects to excellent acoustical design. However, in any space for listening — be it a church, synagogue, concert hall, recital hall, theatre, lecture hall, courtroom, or classroom — strict control of noise is a fundamental requirement. Sources of noise include traffic, airplanes, machinery, plumbing, lights, and people in other spaces. In a space for listening, the worst offender is usually the heating, ventilating, and air-conditioning (HVAC) system.

The human ear is so sensitive that it can detect sounds that displace the eardrum by roughly the diameter of a hydrogen molecule.[3] This means that background noise determines the softest sound that a performer or speaker can effectively utilize.

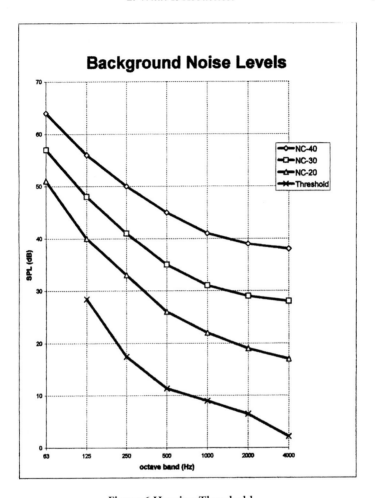

Figure 6 Hearing Threshold

NC (noise criterion) curves were developed to characterize the noise levels of mechanical ventilation systems. They were derived from equal loudness curves (Fletcher Munson curves),[4] which compare objective sound levels (in dB) with perceived loudness for sounds at varying frequencies. Roughly speaking, it takes a more intense low-frequency note to sound as loud as a higher frequency note. A noise with a frequency spectrum that follows one of these equal-loudness curves will not have any pitches that leap out and call attention to themselves. It is said to have a neutral spectrum.

By following these criteria, one can design a mechanical system that creates an acceptable amount of noise without bothering people. Acceptability, of course, depends on the use of a space. An office ought to be

noisier than a lecture room. Neutral noise from the HVAC system can mask conversation, providing speech privacy without calling attention to itself.

NC-40 is considered acceptable for such non-critical spaces as lobbies and corridors. NC-30 would be acceptable for a motel room. NC-20 is often given as acceptable for churches or drama theatres.[5] But look at how much area there is between the threshold of hearing curve[6] and NC-20. There is an awful lot of audible sound being covered up by an HVAC system at NC-20.

Speech

When a theatre is truly quiet, an actor can use his entire dynamic range, from a shout to a whisper, and still be clearly understood. Since the quiet moments in a drama are often the most electrifying, strict control of background noise is essential. In Act Four of Chekhov's *The Seagull*, Treplev sits alone at his desk, silently tearing up his manuscripts. He walks off stage. It is completely still in the theater. Then BLAMM! we hear him shoot himself. For this scene to have its full effect, the audience must be able to hear paper ripping on stage from the farthest seat in the audience: There must be absolute silence!

The ancient Greek theatres are known for their almost magical acoustics for speech. One can hear a drachma drop from the farthest seats in the theatre at Epidaurus. How can this be so? The answer is that no audible sound covers up the sound of the coin striking stone — and so it is heard.

Music

Similarly for music, a silent background allows a performer to exploit his entire dynamic range. The loud climaxes of a musical performance can be wonderfully stirring, but the quiet moments set off these climactic moments and give them their power. Without the quiet moments, music is all on the same dull level. Furthermore, some of the most intense, magical moments in music are the softest. These moments are only possible when the hall in which they occur is truly quiet.

Speech and Music in the Same Space

Many spaces are used for both speech and music, churches being a prime example. For such mixed use, a silent background is particularly

important. This is because reverberation is necessary for music. Without reverberation, music sounds flat and dull. But reverberation can interfere with speech intelligibility by prolonging the sounds of speech, smearing them in time.

A good speaker corrects for this effect by speaking slowly and clearly, working with reverberation to enhance the sound of his voice. However, reverberation also amplifies background noise, creating a double difficulty for speech. Contrary to common belief, speech can work quite well in a properly designed reverberant space, but only if background noise is minimized.

Audience Noise

A source of noise that is beyond the direct control of the architect or acoustical consultant is audience noise. However, research shows that audience members are significantly quieter when background noise levels are very low.[7] In the City of Birmingham Symphony Hall, Birmingham, England — a hall with exceptionally low background noise — audience members are so attentive during quiet music passages that they hold their breaths to listen.

The Common Condition

In the vast majority of places where I listen — churches, theatres, lecture halls, recital halls, concert halls — background noise imposes a haze in front of the sound. This noise is not noticed by most people. Instead, they notice that their experience is diminished: the tone color of the violins is dull; the sound lacks clarity; they cannot quite understand the words.

The effect of background noise can be compared to looking out through a dirty window; one does not notice the dirt on the window, one simply cannot make out the view. When the window is cleaned, the improvement in clarity is striking. And so it is when background noise is controlled. This can be demonstrated easily by first listening in a space with all ventilation systems and lighting on, and then turning these systems off. Note the improvement in sound clarity. For recording, turning off all mechanical systems and most lights is common practice.

The usual response to the ubiquitous blanketing of desired sound by background noise is to turn up the amplification. There are many problems with this approach — which I discuss in the subsection "Why I Hate Sound Systems" in the section "Sound Systems."

What Is to Be Done?

When designing a new space for listening, background noise must be considered from the very beginning. Such issues as the location of noise producing machinery are rarely examined carefully or early enough. For example, an architect once called me to help with the design of a high school auditorium. I discovered that it was too late in the design to move two large air-handlers from their location on the roof of the auditorium. They might just as well have been put on stage! I did my best to help out, but nothing I could recommend for the inside of the room would cancel out the deleterious effect of those two huge noise makers.

In the case of historic renovation, noise control is particularly important for improving acoustics, because it is not possible to alter the geometry. In some cases, drastic improvement may be had by merely quieting a noisy mechanical system. There are, unfortunately, many cases where a perfectly lovely space has been ruined acoustically by new loud ventilation systems. Among old churches this is more often the case than not. When planning the renovation of a worship or performance space, noise control should be the first consideration.

Cost

Cost is a common reason for not sufficiently controlling background noise. However, if one is going to build at all, why cut back on the most important aspect of the design? Noise control is fundamentally important to the success of any building for listening. It can make the difference between excellent sound and the usual mediocrity. On a tight budget, the *first* place to spend money is on noise control. Better to save money by leaving out the seats! After all, these buildings are often meant to last for more than a hundred years.

Conclusion

Few people are consciously aware of background noise, but it is everywhere, and the effect is to vitiate the experience of sound. Therefore, silence is the proper background for performance spaces and houses of worship. To emphasize, the acoustics of such spaces should be considered from the very beginning of design; good acoustics without noise control is like a building without a foundation.

Environmental Noise

Noise

In Longfellow's poem "The Village Blacksmith" he expresses how he was charmed by the sounds of the village blacksmith. These sounds told of a strong, independent character making an honest living by providing a needed service to his community. Others may have found the sound annoying.

Noise can be annoying, or even harmful. At high enough levels, it can damage hearing. At lower levels, the annoyance of noise can cause stress and lack of sleep, even violence and suicide. Noise does not have to be loud to be annoying; it can be extremely annoying even if barely audible. Think of the barely audible thump thump thump of rock-and-roll keeping you awake at 3 A.M.

Fortunately, noise has several distinct advantages over other types of pollution: it is gone as soon as it ceases. It leaves no residue. Furthermore, it usually doesn't travel very far (except in the ocean).

If powerful enough, noise can damage hearing either directly through trauma, or over time. This damage is a function of both sound level and duration of exposure, both of which can be objectively measured. We are all subject, to one degree or another, to the steady degradation of hearing from our noisy modern world. Shepherds on idyllic islands far from civilization can retain the hearing of an adolescent late in life due to their quiet surroundings.

Noise-induced hearing damage varies from person to person due to constitution and exposure. If a sound is intense enough, one can loose hearing immediately. However, lower level sounds can degrade hearing from long-term exposure. Here is a table of permissible noise levels from the Occupational Safety and Health Act (OSHA).[8]

Table 3
Permissible Noise Exposures (1)

Duration per day, hours	Sound level dBA slow response
8	90 dB(A)
6	92 dB(A)
4	95 dB(A)
3	97 dB(A)
2	100 dB(A)
1.5	102 dB(A)
1	105 dB(A)
0.5	110 dB(A)
0.25 or less	115 dB(A)

Keep in mind that these levels are practical standards. I would avoid anything even approaching these exposures. In fact, I strongly urge everyone to use earplugs while driving, using a vacuum cleaner, attending any kind of event with amplified music, doing carpentry: in short any activity where you will be exposed to high levels of noise, especially impulsive noise, such as hammer blows or gunshots. Fortunately, it has become standard for hunters and target shooters to use earplugs when shooting, but the practice is relatively recent.

Noise doesn't have to damage your hearing to be a problem. Noise can be extremely annoying. It can drive people to move out of their homes or even commit murder.[9] When the FBI wanted to drive the Branch Davidians out of their compound in Waco, Texas, they played loud rock-and-roll 24 hours a day. I would have been out of there in no time!

To be annoying, sound must be audible, but annoyance is in the mind of the hearer. Some sounds that are perfectly audible may be considered pleasant (the sound of geese flying overhead on a quiet fall day in a pristine wilderness). Other sounds that are barely audible may be intensely annoying (the sound of a chainsaw in the same pristine wilderness).

Annoyance is a function of perceived loudness, duration, and psychological association. The same chainsaw sound is sweet to the fellow who can chop wood to warm his home with much less effort than if he had to chop wood while producing the charming, rustic sound of an ax. To the vacationer who wants to escape the sounds of civilization for a few days, that chainsaw is a violation. How to balance such conflicting needs and desires is the crux of the noise pollution problem.

We can measure a sound to demonstrate whether it will be audible, though this might be difficult in practice because of the miraculous acuity of the human hearing system. We can easily hear sounds that are well below the level of background noise. Our ability to hear sounds is increased by the fact that sounds rarely coincide in spectrum, location, or timing. It is this ability to pick out sounds from a noisy background that enables one to have a conversation in a noisy crowded restaurant, or that allows the little murmurings from a television in the next apartment or hotel room to be so damnably irritating. A system that worked so well to warn our prehistoric ancestors of predators creeping up on us in the jungle can be a hindrance when trying to get some sleep in spite of inconsiderate neighbors.

Measuring sound levels down at the level of audibility is tricky. To measure a sound source reliably, it needs to be roughly 10 dB over the background. To illustrate why this is true, consider the arithmetic: if you add 50 dB to 40 dB, you get 50.4 dB.[10] Furthermore, natural fluctuations in sound can intermingle background noise and the noise we are trying to

measure. Finally, human hearing is directional, and we are very good at localizing a sound event. Conventional sound level meters have one microphone and just measure whatever hits the microphone. They don't distinguish between the annoying sound of the television next door and the lulling sound of wind in the trees. To a sound level meter it is all the same: variations in air pressure. In order to measure a sound that is barely audible, we move closer to the source until it is more than 10dB above the background. Then we calculate what its level will be in the region of concern.

We run into noise in many situations: in our homes and neighborhoods, at work, when we go out on the town, and when we seek the quiet solitude of nature (good luck!).

Houses are not usually constructed to withstand high levels of noise. They usually have a single outside wall — the younger the house, the lighter the construction — with windows and doors. When the weather permits, it is pleasant to keep your doors and windows open. In a residential neighborhood at night, traffic (the most common source of noise) dies down, so any discrete source of noise is exposed in contrast to the still night.

The most widespread source of noise is traffic. Since traffic is ubiquitous we often don't notice it. In many areas traffic mercifully dies down at night. For people who live under flight paths of airplanes, alongside train lines, or busy highways, however, traffic noise can be a real problem, especially if traffic conditions change.

Someone who moves into a house alongside such a busy traffic artery ought to know what he is getting into. And, people who don't mind a little noise may be able to take advantage of the opportunity to buy a bigger or otherwise nicer home than they could ordinarily afford. Some people, however, may find that the quiet charming country road that they used to live on has become a major highway, jammed with loud trucks at all hours. Welcome to suburban sprawl. That's one reason for living in the city: the noise level stays pretty constant year to year.

Every time an airport plans to expand or change flight paths, large amounts of money and energy are spent studying the effect of noise from low-flying airplanes. Airplane noise is particularly difficult to block because it has so much low-frequency noise that cuts right through something as flimsy as a mere house.

As more and more people move out to the suburbs, abandoning subways for highways, highways become larger and more crowded. Highway barriers can help alleviate some of the noise that is broadcast into the communities by the traffic. These barriers cost a great deal of money. To have one built, it is necessary to convince the state department of transportation that they are worth the cost. When a new highway is being built, or

a route is changed or enlarged, a noise study and a cost analysis are done. If the predicted noise reduction is sufficient, and the cost per number of people is low enough, a barrier will be built. This is how it is done in Pennsylvania, where I live; the exact procedure varies from state to state.[11]

Noise from neighbors is rarely threatening to hearing. Though this may be little comfort when the boom boom boom of your neighbor's teenage son's rock-and-roll wakes you out of a sound sleep at 3 A.M. The issue is really one of manners, of civility. Good neighbors keep their noise to themselves. The difficulty is that people are often completely unaware of the noise that they themselves create. For example, you may like to listen to music. But if I have to hear your music — even if it is music that I might enjoy listening to myself — to me it is noise, because I did not *choose* to listen at that particular time. I believe that the answer to many neighborhood noise disputes is communication. When people feel in control, they are less bothered by noise. For instance, if your neighbor has a noisy party, and you know it will end at 10:30, you will probably put up with it. But if a neighbor has a party, and you have no idea when it will end, and the neighbor has been unfriendly in the past about noisy parties, then the situation is much more annoying.

Some occupations subject workers to levels of noise that are damaging or potentially damaging to hearing. Awareness of this problem has grown tremendously, and these days it is common to see people operating noisy equipment wearing hearing protectors, either foam plugs, or clamshells. To measure industrial noise exposure, a worker may wear a noise dosemeter that records noise exposure over time. Although actual damage varies from individual to individual, tables of allowable levels and durations have been codified and are part of OSHA regulations. Although complying with these regulations costs money, the regulations are clear, objective and easily obtainable. Overall, it appears to me, the benefits of protecting the hearing of a large number of workers outweigh the costs.

Resistance to hearing loss has nothing at all to do with personal fortitude or strong character. The tiny cilia in your ears are not protected by the muscles in your arms or chest; they die from overexposure to high levels of sound whether you are a wuss or Mr. Macho.

Impulsive sounds, such as hammer blows and gunshots, are particularly dangerous to hearing. First, there are muscles in the middle ear that contract and protect the inner ear from high sound levels. Impulsive sounds happen too fast for these muscles to activate, leaving the delicate cilia exposed to the full force of the assault. Second, impulsive sounds are not perceived as being as loud as a longer sound of the same sound pressure level; the person hearing the sound may be less aware of the danger

to his hearing, and thus be less likely to believe that his ears require protection.

Longfellow's village blacksmith probably lost substantial hearing from the repeated blows of his sledge on the metal anvil. It is somewhat ironic that the poem goes on to describe the blacksmith listening in church to the sermon and the choir.

Recreational Noise

We are increasingly assailed by "recreational" noise. Walk into a restaurant or bar, or attend a social function, and the chances are that you will be drowned in pulsating popular "music." As more and more powerful amplification becomes cheaper and cheaper, levels rise. Too often, dinner conversation becomes a shouting match. Levels at dances and clubs are high enough to deafen in a night. Rock concerts have been deafeningly loud long enough to have provoked somewhat of a backlash among performers. In 1988, rock-and-roll musician Kathy Peck and physician Flash Gordon, M.D founded H.E.A.R. to address the problems and dangers of loud music.[12] The organization got a real shot in the arm in the beginning from Peter Townshend of the rock group the Who. Mr. Townshend is now 57, and cannot hear the voices of his children.

Out in the Woods

When I leave the city and suburbs and farmland to visit the woods, the way I know that I am really away is whether I can hear automobiles. There are parks near where I live that are lovely to look at, filled with trees and beautiful vegetation. But to feel that I am really out in the countryside, I have to escape the sound of cars, and motorcycles, and helicopters, and trucks, and lawn mowers, and, chainsaws, and leaf blowers, and jet skis, and snowmobiles, and off-track all-terrain vehicles. This is not easy.

What Should We Do?

No one, except teen-aged boys, makes noise just for the sake of making noise. Noise is nearly always the by-product of something that benefits someone else. The question is: how do you balance the interests of the noisemaker, with those of others who may not wish to hear his noise. The operating principal seems simple: your right to swing your fist around ends at my nose; your right to make noise ends at my ears.

However, in practice it is not so simple. An ambulance racing to bring

a critical patient to the hospital must make a loud noise to avoid traffic accidents. Your right to a peaceful night's sleep is just not as important as saving lives. Nor should a summer vacationer in a rural area expect farmers to cease their noisy operations for his benefit.

On the other hand, I do not believe that the thrill that a few yahoos get from riding around in a snowmobile is worth smashing the still of a peaceful afternoon in the countryside for people 40 miles around. The same goes for jet skis and other noisy forms of motorized "water sports." It seems reasonable to me that wilderness areas that are set aside for the quiet contemplation of nature should ban the use of noisy "recreational vehicles"—unless they are used for emergencies. In a life-and-death situation a little annoyance seems trivial.

The best way to deal with the inevitable conflicts in society is through clear unambiguous laws and regulations that apply equally to everyone. Since noise is local in its effect, it is regulated locally. This can sometimes cause confusion when moving between locations, but this confusion is compensated for by the benefit of local control.

There are essentially two different types of noise regulations: objective and subjective. Objective regulations state allowable levels in terms of noise measurements with a sound level meter, sometimes relative to background noise measurements. Usually the measurement location is the property line.

Subjective regulations define noise subjectively. For example the noise code of Anchorage, Alaska, forbids anyone from creating a "noise disturbance" across property lines. A noise disturbance is "…any sound that endangers or injures the safety or health of humans or animals, annoys or disturbs a reasonable person of normal sensitivities, or endangers or injures personal or real property."[13]

Objective codes would seem to be a better, clearer approach. After all, who is to say what a "reasonable person of normal sensitivities" is? And don't people with abnormal sensitivities have the right to be protected from noise too? The problem with objective codes is that our ears just don't work like sound-level meters. To take meaningful measurements, the conditions of measurement have to be clearly defined: when, where, meter settings, etc. Otherwise apples are being compared with oranges. But it is extraordinarily difficult (perhaps impossible) to objectively define a sound that a reasonable person of normal sensitivities would find objectionable. Add to this the fact that measuring sound requires expensive equipment and training to operate the equipment correctly. One danger with objective measurements is that they can create a legal shield for people creating annoying noise that just happens to meet code.

Many codes have both objective and subjective definitions. This is probably the best way to define noise, but it is certainly not unambiguous.

Practical Measures

There are three ways to control noise: at the source, by blocking the path of sound, and by protecting the hearer. Reducing or eliminating the source is obviously the best method, if it is possible. But it is not always possible or feasible or desirable to eliminate all sources of noise. We have to eat and we have to make a living and we want to be able to travel faster than we can walk. Transportation, growing food, and making things all create noise to one degree or another.

Controlling the noise path between source and receiver is often the most practical way to control noise. Highway noise barriers, sturdy windows, enclosures around roof-top mechanical equipment are all barriers to noise sources. Noise barriers, to be effective, must be sufficiently massive and large. Contrary to widespread wishful thinking, it is not possible to "suck up" noise with some magic material. Outdoor noise is particularly difficult to block since the path of sound through the air can bend over and around barriers due to temperature gradients in the air. Amplified music is particularly difficult to deal with because of the low frequency pulsation of the electric bass. Low frequency sounds bend around barriers and are not attenuated in the air.

An interesting approach to dealing with the sound generated by amplified music from open-air amphitheatres is to monitor the sound with meters mounted in surrounding areas. When the measured level is too high, the system automatically turns the level down. It is completely beyond me why anyone would want to destroy his ears listening to music at levels so high that it can be heard in the next town. People do all sorts of crazy things.

In industrial situations, where noise is an inevitable by-product of the task at hand, barriers to protect the ears of workers are often required. It is possible to reduce the din in a large noisy room like a factory with sound-absorbing material, but this may not be enough for someone who must work close up to a noise-producing machine. These noise barriers can take the form of enclosures around machines, or barriers between the worker and a small noise-producing location. The most common noise-protectors are earplugs and clamshells.

For musicians who must be able to play and still protect their ears from potentially damaging levels of sound, it is possible to buy earplugs

that are designed to reduce sound equally across the spectrum so that it is easy to play with the earplugs in place. This is a great improvement over conventional foam earplugs, which attenuate high frequencies much more than low frequencies and so sound muffled.

Since so much annoying noise is electronic in origin, the best approach to noise control is often the simplest: just turn down the volume.

Noise and Vibration Control

If it is not possible to just turn off the source, we are left with two tools to control noise: we can absorb sound, and we can block sound from traveling from one place to another. These two are often confused. To clarify the distinction, imagine a room with a door. If I want to absorb sound being produced in this room I will open the door. All sound striking the door opening will travel out of the room never to come back. It has been, effectively, absorbed.

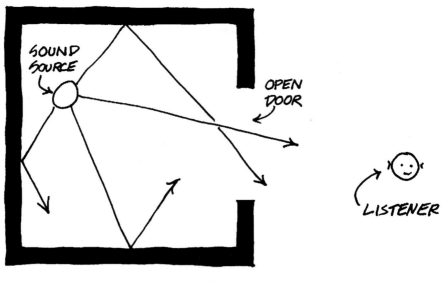

Figure 7

On the other hand, if I want to prevent sound in this room from traveling to a space on the other side of the door, I close the door. Heavy, airtight constructions do the best job of blocking sound.

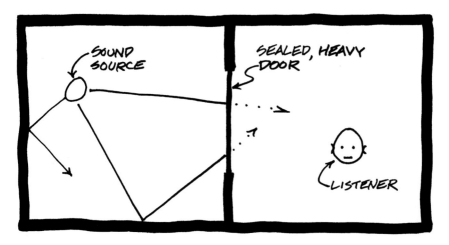

Figure 8

Sound absorbing materials (such as drapes or fiberglass) do not block sound very well, since they must be porous to do their job. Sound must travel through a material in order to be absorbed. Even with the best sound absorbers, a lot of sound still passes through the material and comes out the other side.

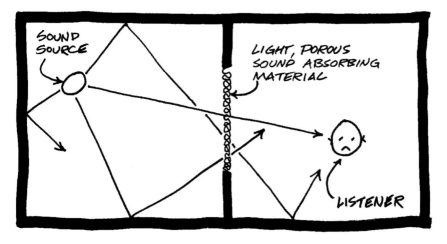

Figure 9

For loud sounds or quiet spaces, a single wall will probably not be sufficient. Even a solid masonry wall will allow sound to pass through. It is usually necessary to isolate spaces with two separate, solid walls. For

critical listening spaces, even this will not suffice. Remote location of noisy machinery is essential because of structure-borne vibration.

In practice, we often combine sound blocking and sound absorption. This is probably the root of the common confusion between the two approaches. To prevent sound from traveling from one space to another often requires both a heavy, airtight barrier between the two spaces, as well as sound absorbing material within the sound-producing space.

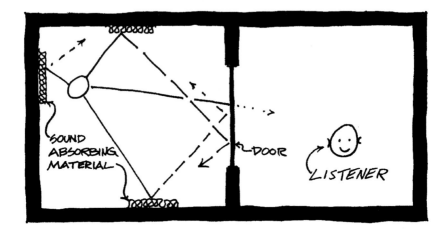

Figure 10

Vibration Control

Vibration control is related to noise control because vibration can either be perceptible by itself, or it can create noise. Vibration is basically sound being transmitted through a solid medium, rather than air. The term vibration includes frequencies that are lower than we can hear as sound. Vibration can be radiated from a surface into the air and become audible sound, or it can be felt directly. Sound travels much faster and more effectively through solids than through air. The speed of sound in concrete, for instance, is roughly 10,000 feet per second, ten times the 1,030 feet per second for sound in air. Remember the old trick of putting your ear to the track to hear the approach of a distant train? The sound and vibration travel much more effectively through the solid rail than through the air.

The hum of transformers or the vibration of ventilation machinery can travel long distances through a building structure and will seriously degrade listening conditions in a critical listening space. To prevent these

machines from being audible, it is necessary to mount them on resilient pads (made of rubber, neoprene, cork, fiberglass or felt) or springs. It may even be necessary to mount them on a structurally independent part of the building. This may sound extreme, but buildings are often built in structurally independent sections so they won't crack when different sections settle into the ground at different rates. New additions always have expansion joints to allow the two structures to move independently. Structural isolation sufficient to interrupt the transmission of vibration requires more care than the usual expansion joint, but it is essentially the same.

Vibration can be radiated as sound from a solid surface. This can be clearly heard if you strike a tuning fork, hold it up in the air, and then place its end firmly on a table. What was previously barely audible suddenly sings. Imagine what happens if you place a strongly vibrating air-conditioning unit on the roof of an auditorium. The entire roof acts to radiate noise into the seats below.

Source Path Receiver

Noise problems are classically considered in terms of three aspects: source, path, and receiver. We treat the receiver by, for example, using earplugs or over-the-head ear protectors when mowing the lawn or practicing marksmanship at a shooting range. This approach is not recommended for dealing with noise in concert halls. Highway barriers or well-sealed doors treat the path. As discussed above, you can block sound or absorb sound to deal with noise as it travels along a path from source to receiver.

The most effective means of dealing with unwanted sound (noise) is to treat the source. Choose a quieter machine; move it farther away; improve its performance; or find a quieter alternative. A great deal of effort goes into the design of quieter machines. Apple Computer, for example, recently figured out how to cool a computer without a fan, using passive ventilation, to radically reduce the noise created by their top-end machine. A similar approach can be applied on a larger scale to quietly ventilate buildings. In sunny southern Spain, many of the older buildings have inner courtyards open to the sky, often filled with plants, or even a fountain. These courtyards encourage the flow of air, drawing hotter air out of the building, silently cooling and ventilating.

Background Noise in Listening Spaces

Noise control is fundamental to the design of a performance space or house of worship. The background noise level of such listening spaces

determines what level of acoustical quality is possible. Background noise is created by factors such as the location of mechanical heating, ventilation and air-conditioning equipment, the budget for these mechanical systems, and the nature of the wall constructions. Good space planning is fundamental. These are all issues that are determined very early in the process of design. The time to think about noise control in listening spaces is right from the very beginning.

Measuring Sound

Although there are many ways to measure sound, there are two basic types of acoustical measurements that may be useful for the architect: sound level measurements and room acoustics measurements. Sound level measurements tell us the level of a sound. (This is not exactly the same thing as its loudness, which is subjective.) By comparing sound levels we can also determine how much sound is attenuated by a barrier or by distance. Room acoustics measurements tell us how a room affects sound created in the room.

Sound in the world around us changes constantly. One seldom has the luxury of measuring a sound that is static. Not only does the level change, but also the frequency. In fact, nearly all sounds that we hear are composed of many frequencies mixed together. This mixture of frequencies (called the spectrum) is also continuously shifting. You may know from your experience that the sound of a piccolo is different from that of a tuba. Imagine trying to measure the sound of an orchestra. The overall levels as well as the relative levels of different frequencies are constantly shifting. This constant change is what makes music possible.

Occasionally, one measures sounds that are reasonably steady. For the most part, however, even sounds that at first appear to be constant — such as steady traffic or mechanical ventilation noise — are revealed to be in flux by the wavering dial of a sound level meter. So how does one take this complex and protean phenomenon and capture it in terms that balance precision with utility?

Sound Level Measurements

A complete description of the sound of an orchestra (at a particular location) would be a recording of the orchestra. Such a level of detail is not necessary for architectural decisions. Suppose we want to build a rehearsal room for an orchestra adjacent to a classroom. How do we measure the sound of the orchestra in such a way that will help us design an appropriate wall

construction? It is not just the most powerful sounds produced by the orchestra that would be important. The spectrum would be important, too, because frequency affects how sound penetrates walls. It would also be useful to know how often these most powerful sounds occur. It may not be worth the expense to build a construction to contain the most powerful sounds if they happen rarely.

To measure requires units. The unit for sound level is the decibel (dB): a tenth of a Bel, named after Alexander Graham Bell. Decibels are logarithmic, similar to the Richter scale used to measure earthquakes. This approach makes sense because our senses work proportionally.

This proportionality of our senses can be illustrated by the following simple experiment:

Heft a penny to feel its weight. Then add another penny. You should be able to feel the difference. Now hold a brick in your hand and add a penny on top of the brick. You will not notice the additional weight. Our perception of loudness works in the same proportional manner. A very quiet sound is audible in a relatively quiet background, but the addition of the same sound is inaudible if the background sound level is higher.

A decibel measurement only makes sense if you define its spectrum. A broader spectrum allows more energy into the measuring device and thus results in a higher reading. Fortunately, the relationship between decibel levels and frequency range has been conventionalized. The most common way to define the frequency range of a sound level measurement in decibels is the A-weighted decibel level, or dB(A). When the term dB is loosely used to describe sound levels, what is usually intended is dB(A). dB(A) is a very convenient and common unit for describing sound level. It is useful because it is conventional, and because it is a single number representing the level of an entire spectrum, weighed to reflect the sensitivity of human ears.

We hear very well in the frequency region covered by the high end of the piano and much less well at lower frequencies. This is a good thing because if we heard low frequencies as well as we heard high frequencies we would be constantly distracted by the sound of our hearts pumping and blood rushing through our veins. So, when we measure sound in dB(A), the lower frequencies are discounted. Although detail is lost in collapsing a spectrum into a single number, the single number dB(A) is very handy, especially for taking a large number of measurements. For this reason, community noise measurements are often taken in terms of dB(A).

ABSOLUTE SOUND LEVEL MEASUREMENTS

Absolute measurements are usually taken to determine an existing level of noise as a basis for calculating measures to control that noise. One

might measure sound levels at a building site to determine appropriate wall, door, and window constructions. This is particularly important for a noise-sensitive space in a noisy environment, such as a church near a highway, or a concert hall in a busy city. After the building is up, one might take measurements within the quiet room to determine if noise control measures have been effective.

Perhaps the most common — and controversial — noise measurements are those taken after members of a community have complained about noise from noise sources such as an airport or factory. The results of these measurements can determine if the owner of the noise source will have to spend huge sums of money to contain the noise or face crippling fines.

Absolute sound levels are not really absolute; they are relative to a standard. In fact the term "level" always refers to a quantity relative to a reference quantity.[14]

RELATIVE SOUND MEASUREMENTS

Relative noise measurements are used to determine sound transmission between locations, two rooms, for example. These measurements can be used as a basis for calculations to design improved sound isolation between the spaces, or to check if such calculations are correct. To take transmission loss measurements, a noise is created in one room, and measured in both rooms. The difference (taking the area of the wall and the reverberation of the two rooms into account) is the transmission loss between the two rooms. For these measurements, a source of noise powerful enough to be measured over the background noise in the room where the measurement is being taken is required.

Another single number index called the Sound Transmission Class (STC) Rating is used to categorize the sound transmission characteristics of building constructions such as windows, doors, and wall types. Similar to dB(A), the STC rating is an attempt to take a spectrum and reduce it to a single number by relating it to the performance of the human ear.

Because STC ratings underrepresent low-frequency noise, one must take them with a grain of salt. This weighing of frequencies (similar to dB(A)) is based on the fact that we do not perceive low-frequency sound as well as we do higher frequencies. One very common source of noise — rock music — contains large doses of low frequency noise. Unfortunately, the mid range of the bass guitar coincides with a region where our ears are still sensitive, yet the frequency is low enough to penetrate most walls easily. Furthermore, STC ratings are taken from laboratory measurements. Real constructions contain gaps and other paths for sound to flank around.

Because of this, laboratory STC ratings can be up to 17 dB higher than ratings based on measurements in the field.

Room Acoustics Measurements

There are many ways to measure how a room affects sound produced within it. All are refinements of reverberation time, which I address throughout this book.

Reverberation time is the rate at which sound decays in a room once the source has abruptly ceased. Specifically, it is the number of seconds it takes for sound to decay by 60 dB, which is why it is sometimes referred to as RT-60. In practice, it is the time it takes for sound to decay by 30 seconds, times two. In a given room, this rate varies with frequency. Reverberation time is the most common way to characterize the acoustics of a room.

Reverberation time was discovered by Wallace Clement Sabine, the father of modern architectural acoustics. In 1895, Sabine was engaged by Harvard University to remedy the acoustical difficulties with the just-completed lecture room of the Fogg Art Museum.[15] In the course of his investigation, he discovered the principle of reverberation time. The seat cushions from the nearby Sanders Theatre, which he used as sound absorbers in his investigation, were the first units of sound absorption. Sabine went to on to advise the architectural firm McKim, Mead and White on the design of Boston Symphony Hall — still considered one of the very best symphony concert halls in the world.

Reverberation time is measured by creating a sound in the space being measured, and stopping it abruptly. Measurements are taken while the sound is being generated and after the sound source ceases. The levels and time of measurement give the rate of decay. This is done in a crude form by clapping one's hands in a room and listening to the sound decay.

To measure reverberation time, I have used a variety of sound sources, including popping balloons, and a blank pistol. Currently I use a pink-noise[16] generator broadcast through an omnidirectional loudspeaker. People have dropped books as a sound source, and set off yachting cannons (in really large spaces like stadiums).

The concept of reverberation time implies that sound decays simply, in a straight line. This is true enough to be useful in many rooms. However, in complicated spaces, sound does not decay in a straight line. The most audible example is a "dead" room that is coupled by an opening to another, more reverberant room. The sound will decay rather quickly in the "dead" room, but the persistence of sound in the more reverberant room is audible in the "dead" room. If you happen to have a well-furnished

Figure 11

and carpeted living room next to a "live" stairwell, you may be able to hear this firsthand by clapping in the living room and listening to the sound return as it reverberates in the stairwell.

This use of two differing coupled spaces has been very successful in several multipurpose performance halls in providing reverberation with clarity. This effect is not accurately measured using reverberation time.

By closely inspecting the reverberation curve, one can get a more detailed look at how sound is reflecting around a room on its way from source to microphone. With a device called a TEF (time energy frequency) machine, one can see the arrival at the microphone of individual sound reflections. These types of measurements treat the room as a sort of filter, which alters the sound between the source and the receiver by adding a series of sound reflections. More detailed measurements are very useful in fine-tuning a sound system or investigating speech intelligibility.

It is important to keep one's head firmly screwed on and one's ears open while taking measurements. It is easy, for instance, to misinterpret microphone noise or wind noise as source noise. When performing noise measurements, a long enough sample must be taken to ensure that the

conditions being measured are typical. To acquire valid reverberation time measurements, one must fill up the room with sound. Although the data acquired through measurements is very useful, proper interpretation can be tricky.

Measuring Sound Systems in a Room

Un-amplified instruments or people talking and singing in a room move around — even if they remain on stage. This provides an extraordinarily complex situation for measurement. And so one usually measures characteristics of a room that are similar throughout the room. The background noise in an auditorium, for instance, is fairly level throughout the room as soon as you get away from a particular source, such as an air supply grill. Reverberation time is (theoretically) similar throughout a room. The only reason for taking point to point specific measurements in a room for un-amplified performance is scientific curiosity. Design is served well enough by more general measurements and observation.

With loudspeakers, on the other hand, one can utilize very precise measurements because the loudspeakers stay where they are. Let's look at some of these measurements and how they can be put to practical use.

The first method is to just play something through the system and listen while walking around. Sources for playback include: recorded speech or music, various kinds of noise, and a person speaking into an open mike. These direct methods can tell you a lot about how the system is working in the room. Listening can tell you if all seats are being reached, if there are locations where sound is unclear. You can hear echoes, or interference between loudspeakers. Since there is never time enough to measure everything from every location, they also give you a sense of what would be worth measuring.

Sound levels can be measured, as discussed above, from a stable source (like pink noise) through the system to see if sound levels are reasonably even throughout the seating area.

With a TEF machine, speech intelligibility can be measured objectively. Measuring speech intelligibility directly with human listeners is very tedious, and suffers from too much reliance on the inconsistent behavior of human beings. An objective measurement such as the Speech Transmission Index (STI) is useful for providing a reproducible benchmark.

By visual inspection of the impulse response of the system in the room between a loudspeaker, or loudspeakers, one can find echoes and see the timing and amplitude of sound from other loudspeakers. The interpretation

of the impulse response is a difficult art, but it can be a tremendous tool for cleaning up the sound from a system in a difficult room.

Lastly, the sound from a sound system in the room requires equalization. This term refers to the use of a bank of filters that help correct for anomalies in the frequency response of the whole system (microphone, electronics, loudspeakers, room) to create a well-behaved system. Equalization can be used to promote speech clarity by reducing frequencies that contribute less to speech. It can help reduce feedback (the screeching one hears when an open mike is turned up too high). Equalization is an important tool, but it ought to be the last resort, rather than a band-aid for bad design. Equalization is performed by feeding pink noise (sound with equal energy per octave) into the system; measuring the results with a microphone in several locations in the room; and adjusting with a real-time analyzer until the resulting spectrum is what one is seeking. After this process, one must go back and listen.

When all is said and done, the most important measuring devices are attached to either side of one's head.

Visualizing Sound

The most difficult aspect of working with sound is that it can't be seen. People have dealt with this problem in many imaginative ways over time. With our easy access to astonishingly powerful electronics and computer graphics, it is difficult today to imagine how researchers investigated sound before these tools were available. Yet it is amazing how much was accomplished in acoustics before the advent of electronic measuring devices.

CHLADNI PLATES

In 1785, Ernst Florens Friedrich Chladni was investigating the vibration of plates.[17] He discovered that when he sprinkled sand on top of a metal plate, then bowed the edge with a violin bow, beautiful symmetrical patterns emerged on the plate. The bow causes the plate to vibrate. But the whole plate does not move all at once. It bends and flexes. Areas of the plate that move shake off the sand. Stationary areas, called nodes, allow the sand to remain. The resulting patterns reveal the vibration modes of the plate.

Chladni plates can now be found in many children's museums. They are relatively simple to construct. Simply fasten a metal plate using a nail or screw driven through its center to a thick wooden dowel that is mounted on a base. Sprinkle sand (or salt) on top and bow the edges with a 'cello

Figure 12

bow. You can also use a hacksaw with a rosined string instead of a metal blade. It is a little tricky to get the feel of bowing the plate, but when you do get it vibrating, the lovely Chladni patterns appear. Bowing in different locations on the edge changes the patterns.

ROOM MODES

Nowadays, we have the tools to hear the three-dimensional equivalent to vibrational modes of a plate in the vibrational modes of a room. The easiest way to do this is to use a tone generator program on a computer with a sound card. A free downloadable tone generator is available, for example, at http://www.nch.com. au/auction/index.html.

Your computer can be used to generate a sine wave with a frequency between 50 and 125 Hz (you type in the frequency and choose the button that says sine). A sine wave is a pure tone. If you move your head around in the room, you will hear that the strength of the tone varies considerably with location. The intensity is always highest in the corners of your room. Moving your head around, you can hear how the peaks and valleys of sound intensity mirror, in three dimensions, the two-dimensional patterns revealed on the Chladni plates. These patterns of more and less intense sound are called room modes. Changing the pitch will change the pattern. The larger the room, the lower the pitch needed to make audible patterns.

Room modes occur because sound waves bounce off the boundaries of a room. When they reflect they meet sound waves bounding off other boundaries, like water waves sloshing against the walls of a bathtub. Sound waves are composed of alternating regions of high and low pressure, just as water waves are alternate regions of high and low water height. When regions of high pressure in one wave meet regions of high pressure in

another, the two waves reinforce each other. They are in phase. When regions of high pressure meet regions of low pressure, they cancel out. They are out of phase. When the cancellation is exact, two sound waves can combine to create no sound at all. This is called a node. This can be seen on the Chladni plates as nodes where vibration modes out of phase cancel each other out, leaving the sand undisturbed.

When you play a pure steady tone in a small room, you should be able to find locations where the waves cancel, by moving your head about and listening. You can even place your head so that there is sound in one ear, but not in the other. It sounds pretty strange.

These modes are very important in the design of small rooms for recording or mixing because they seriously color the sound of the recording. It is interesting that we are not aware of these room modes in daily life, even though they occur in every room. The only way to become aware of them is to sound a single tone.

STANDING WAVES IN A TUBE

Sound modes can also be seen in a clear tube. You need the same tone generator on your computer and a clear plastic (acrylic) tube, several feet long. Cut a circular hole the size of the tube in a piece of cardboard large enough to cover the front of the loudspeaker. Tape the tube to the cardboard and attach the cardboard in front of the loudspeaker with duct tape or masking tape. Make an airtight connection between the speaker and the tube. Grind up some Styrofoam and scatter a layer along the bottom of the tube. Ground-up Styrofoam makes quite a mess, so spread newspaper underneath it. Generate tones into the tube. At most frequencies, the Styrofoam just jiggles around. But at frequencies that are integer multiples of the fundamental wavelength of the tube, the Styrofoam really stands up and demonstrates the standing sound waves in the tube.

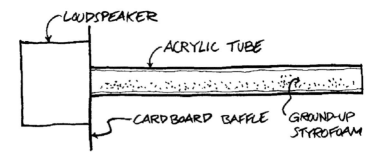

Figure 13

How do you find those frequencies? You can just play around until you find the ones that work, or you can calculate the resonant frequencies (also called natural modes) of the tube. These are integer multiples of the speed of sound (1,130 feet per second) divided by four times the length of the tube. In more concise terms the $f_n = n(c/4L)$, where n = 1, 2, 3, ..., c = 1,130 feet/second, and L= length of the tube in feet. The results of this little calculation will be a little off because the simple theory doesn't take into account the distance between the end of the tube and the loudspeaker cone. By playing around you can really see that sound is pressure waves as it makes those little grains of Styrofoam dance.

SCHLIEREN METHOD

In 1864, Toepler demonstrated that parallel light rays crossing a sound field perpendicular to the direction of the sound field created dark and light bands of light. "Schlieren" is the term for "streaks" in German.[18] These bands of light could be seen on a projection screen. Since sound travels too rapidly for the human eye to see, this light has to be photographed, filmed, or (nowadays) videotaped for the sound waves to be visible.

What the schlieren method actually makes visual is the refraction of light by changes in density in the air. Sound is waves of pressure variations in air, and these pressure variations also affect density. These density variations cause light waves to bend (very slightly). The schlieren method blocks light wave that bend below a barrier, making the pressure changes visible as bands of dark and light (or streaks). This indirectly makes the sound wave visible. A strobe or fast camera catches the fleeting sound wave so that we can see it. In addition to visualizing sound waves, this method can also be used for wind tunnel research, to study fluid and air current flow, to analyze the internal character of glass, for flame analysis, and to determine the mass of microscopic particles.[19]

I have seen filmstrips of sound waves moving within various shaped boundaries, and the effect is striking. In particular, a sound wave traversing a curved border actually rolls along like a ball. There is something wonderfully immediate about seeing, albeit indirectly, real sound waves moving through space.

Acoustical Models

Models are both useful and intriguing. Architectural models date back at least to the ancient Greeks, who built models of architectural details. There is evidence that scale models were used in the Middle Ages; and in

the Renaissance elaborate and beautiful wooden models were built of entire buildings as well as important details.[20]

There are two basic types of acoustical models: physical scale models and computer models. Each can be used to study objective measurements, or sound can be synthesized in the model in order to predict what sound will be like in the finished room (auralization).

What Do We Model?

Why model a room? The answer is to get some useful idea of how a finished room will sound before actually building the room. We talk about how a room sounds, but the room doesn't sound on its own (at least it ought not to); the room sounds by affecting sound produced in the room. It does this by adding sound reflections to the original sound. You can hear this by clapping your hands in a room.

IMPULSE RESPONSE

If you clap your hands or shoot off a blank pistol in a room and record the sound, you can hear how the room enhances the single impulse of the hand clap or pistol shot by adding sound reflections. In a physical scale model, an electrical spark is often used to create an impulse. This room-enhanced impulse is called the impulse response.[21] Every pair of source and receiver positions will have a different impulse response, even in the same room. We know from personal experience (and ticket prices) that sound varies from seat to seat in a performance hall.

AURALIZATION

By creating an impulse in a scale model, one can then record the impulse response, scale it up to full size, and analyze it for objective measurements or use it to model the sound in the real room for listening (auralization). Earlier researchers visually inspected graphs of the recorded impulse response for reverberation time and obvious echoes. J.P.A Lochner and J.F. Burgher, working in South Africa, developed a way of digging yet more information out of the impulse response.[22]

By creating artificial sound fields in their laboratory, Lochner and Burgher studied how sound reflections in a room are related by the ear to the direct sound. To audition these fields, they placed a listener in an anechoic chamber surrounded by loudspeakers. A recorded sound was played through one of the loudspeakers and then, after a short delay and some attenuation, played through other loudspeakers. Using this approach, Lochner and Burgher were able to study the subjective response to the

impulse response (or, more precisely, sound modified by the impulse response), and to develop criteria based on relationships between early and late sound reflections. These relationships can be studied in the impulse responses from models and used to predict the performance of the full-sized room. Their work is the basis for many of the objective criteria used in both model and full-sized room research, as well as techniques to make these measurements audible.

To denote the creation of artificial sound fields, Mendel Kleiner coined the term "auralization," meaning "the process of rendering audible, by physical or mathematical modeling, the sound field of a source in a space, in such a way as to simulate the binaural listening experience at a given position in the modeled space."[23]

WAVES VS. RAYS

There are two ways to think of sound in a room: as waves and, geometrically, as rays. The mathematical description of sound as waves is more accurate, but rays are more convenient. Physical scale models model sound as waves—actual sound waves, in fact. Although some computer approaches deal with sound as waves, most architectural acoustics computer models treat sound geometrically. Much current research is devoted to incorporating the wave behavior of sound into computer models.

Water ripple models

Acoustical scale models date back to Scott Russell's water wave studies in the 1840's.[24] Russell built wooden models of the silhouettes of the rooms to be studied. These models were placed in a shallow tank of water so that a pool of water would form within the model walls. Carefully disturbing water at one point would create a single wave that propagated along the surface of the water and reflected off the wooden walls of the model, revealing wave behavior within the form being studied. To increase clarity, Russell placed a light below the glass bottom of the tank. By taking a series of photographs, the progress of the wave through time could clearly be seen.

Water waves differ from sound waves in one important aspect: water waves of different frequencies travel at different rates of speed, whereas the speed of sound in air remains constant at all frequencies. In order to obtain a clear image and avoid the confusion that would be caused by water waves propagating at various speeds, one must carefully pluck the water to get a single wave. This can be done by cleanly pulling a small pointed object out of the water, or by allowing a small droplet to fall into the water.

Using this method, Russell and others were able to investigate both longitudinal and cross sections of auditoriums. They investigated the effect of various ceiling shapes, sound under balcony overhangs, and the effect of diffusing shapes like coffers. Since the models were relatively easy to build, alternative shapes could be explored. The water wave method is limited to two dimensions and gives visual information. As far as I know, it is no longer used.

Sabine's Spark Photos

In 1913, Wallace Clement Sabine, the father of modern architectural acoustics, adopted the schlieren method for investigating the propagation of sound in auditoriums.[25] Sabine built silhouette models similar to Russell's water wave models in order to study the effect of the shape of an auditorium on sound. His apparatus consisted of two sparks in a lightproof box, with the model at one end. One spark produced the sound. The second, slightly delayed, produced the light for photographing the sound traversing the model. The light spark was back far enough so that its sound reached the model too late to interfere with the sound from the sound spark. By adjusting the delay of the light spark, Sabine was able to take surprisingly clear photos of an actual sound impulse traversing the model space.

The results of this method bear a striking resemblance to the water wave method, but sound waves are much clearer than water waves. The tremendous advantage of this approach is that one can see actual sound waves. The disadvantage is the same as the water-ripple method: restriction to two-dimensional visual information. The schlieren method is still used to investigate heat transfer in air and other fluid-mechanics issues that are as yet imperfectly understood mathematically. I believe that this approach still has possibilities for architectural acoustics investigations, but I know of no one currently using this method in architectural acoustics.

Light Models

The earliest investigations of sound in three-dimensional models were done using light as a proxy for sound.[26] Sound-reflecting surfaces are modeled by light-reflecting materials. A model can be built of light-reflecting material, such as polished aluminum, or the surfaces of an existing model can be covered with a light-reflecting material. A lamp or laser is used to model the sound source. Light models are very useful for locating and orienting sound-reflecting panels in auditoriums, for instance. Another

approach uses a sheet of ground glass placed on the audience plane; the intensity of light reflections models the intensity of sound reflections. The model can also be filled with smoke to illustrate the path of the light rays through the model space.

The light-ray method also has its limitations. Light is not sound, and the speed of sound is an important aspect of acoustical design. Echoes (for instance) are audible because sound is relatively slow, whereas the time for light to travel human-scale distances is essentially zero. So the light-ray approach gives no information about relative arrival times of sound reflections. Also, sound bends around objects that are small relative to wavelength, whereas light wavelengths are so small that very little bending is visible.

The light-ray approach does, however, have a few strong advantages. It is very hands-on; you can learn a lot by getting in there and poking around, moving parts of the model about. These models can be small and therefore relatively inexpensive (especially if an architectural model has already been constructed). More accurate but cumbersome types of models are often too expensive to build often enough for the necessary back and forth of the design process. The ease and flexibility of the light model method makes it more likely that model studies will actually influence the design.

Acoustical scale models

The first three-dimensional model studies using sound were done by F. Von Spandöck[27] in the 1930's. Spandöck started with 1:5 models of three rooms. He continued his investigations in his laboratory in Munich with 1:10 scale rooms. He played recorded sound into his model rooms, then listened to recordings taken from the model. The recorded sound was scaled to the size of the 1:10 model by speeding up the tape to ten times the original recorded speed. This produced sound with 10 times the frequency ($\frac{1}{10}$ the wavelength). The sped-up sound was re-recorded with microphones in the model; the resulting tape was played back for listening at $\frac{1}{10}$ speed for auditioning the model.

Acoustical scale models are possible because the speed of sound is constant in a given medium: speed = distance/time = frequency × wavelength.[28] In a model, reducing distance and increasing frequency by the same factor results in the same behavior. A sound wave will bend around an obstacle that is one quarter of its wavelength no matter what the absolute size of that wavelength. A perfect scale model will perfectly model sound in the real room, since sound acts the same regardless of scale.

Some things, however, are easier to scale than others. Scale models pose all sorts of intriguing puzzles for researchers. For example, materials, including air, absorb sound at different rates depending on frequency. Early on, this difficulty was dealt with by ignoring the sound absorption in air, and by using two types of materials: totally sound-reflecting and totally sound-absorbing. This worked reasonably well for concert halls built mostly of very hard surfaces with a sound-absorbing audience. More precise measurements of objective criteria such as reverberation time or auralization require scale modeling of sound-absorbing materials. Spandöck spent subsequent decades investigating sound-absorbing materials for use in scale models.

AIR ABSORPTION

Since air absorbs sound much more at higher frequencies than at lower frequencies, air absorption at higher frequencies seriously affects the results of scale model studies. Smaller models require that sound be scaled up to higher frequencies, exacerbating the problem of air-absorption.

To avoid this air-absorption problem, early investigators were restricted to models ¹⁄₁₀ the scale of the room being studied. ¹⁄₁₀-scale models are huge and expensive both to build and store. Later researchers dealt with this problem by drying the air,[29] or by replacing it with nitrogen. Both approaches reduce high frequency sound absorption. Later, Polack, Marshall and Dodd developed a method for compensating for air sound absorption using digital signal processing.[30]

TRANSDUCERS

Another challenge was the development of miniature transmitters and receivers. Early sources of sound included miniature loudspeakers, spark sources, and even miniature air-jet nozzles.[31] These sources may look small, but at model scale they are large enough to affect the directionality of sound. Directionality of both sources and receivers strongly affects the behavior of sound in a room. For example, an orchestra may be modeled as sound coming out of two miniature loudspeakers, but the directionality of the many instruments of a real orchestra on stage is vastly more complex than that of two loudspeakers. In a concert, we can easily hear the precise location of the piccolo player out of the dense fabric of the orchestra; this can't be modeled with two loudspeakers.

The directionality of receivers (microphones or ears) also has an audible effect. Human hearing is exquisitely sensitive to direction. To provide directionality that is more accurate for model receivers, Ning Xiang working with Jens Blauert at the Ruhr University at Bochum, Germany, developed

the first workable miniature model of the human head and shoulders designed for taking measurements in full-sized auditoriums.[32]

Computer Models

Computer modeling of room acoustics has become increasingly common as computer memory and processing speed continue to grow exponentially, and as computer modeling and drafting have become the norm in architecture. I now use a computer model for all my room acoustics work ranging from simple reverberation time calculations to loudspeaker coverage and investigation of room geometry.

RAY TRACING

Early investigation of computer modeling of room acoustics was done by Manfred Schroeder, B.S. Atal and Carol Bird at Bell Laboratories.[33] They synthesized sound fields based on a manual study of drawings, plus a reverberant field calculated using Monte Carlo methods, which are (as the name implies) approaches that use randomness to approximate complexity. They added sound reflections to a direct sound and then played back the result to a listener in an anechoic chamber through two loudspeakers. In their combination of ray tracing for early sound reflections, with a random reverberant tail, the researchers in this seminal study foreshadowed the most up-to-date approaches to computer modeling.

In 1968, A. Krokstad, S. Strom and S. Sorsdal from the Technical University of Norway, Trondheim, published a paper on the ray-tracing method of computer modeling of sound in rooms.[34] Ray tracing on paper is one of the oldest techniques of room acoustics[35] and is still a staple of room acoustic design. Based on the concept that the "angle of incidence equals the angle of reflection," one can trace the course of sound as it is reflected around a room. To simulate scattering, one can send the reflecting ray off at a random angle.[36]

Computer ray-tracing programs calculate the sound at a receiver location by broadcasting sound rays from a hedgehog-like source. These rays are traced through a series of reflections until they arrive at the receiver location, die in the sound-absorbing audience, or run out of their quota of reflections. The receiver location has to be defined as a small volume, since sound rays would never arrive *exactly* at a particular location.

Early ray-tracing programs were used to investigate room shaping and, like early wave models, only provided visual information. These early ray-tracing model studies provided some of the best concrete evidence for the weakness of the fan-shaped plan for concert halls. In early programs,

surfaces were modeled as either totally reflective or totally absorptive.[37] Later developments include more precise sound-absorption for surfaces, directionality of sources, and even the scattering of sound waves by surfaces and the shapes they create.

IMAGES

B. M. Gibbs and D.K. Jones, when at the Sheffield (England) University Department of Building Science, published a paper describing an alternative way to calculate the sound field in a room using a computer: the images method.[38] The best way to visualize this approach is to imagine being in a room that is built completely of mirrors. If you have ever been in a room with mirrors on several walls, you will have noticed that the reflections have reflections that seem to recede into infinity. These reflections appear to be images in an adjacent room. Sound reflections behave in a similar way. A room with sound-reflecting walls can be modeled as a room with a series of adjacent rooms containing images of the source. Adding up the sound contributions from all of these images gives you the sound at a receiver location. The absorption of reflected sound is modeled as a loss as the sound from an image crosses the imaginary boundaries. One of the challenges of this method is that not every image is "visible" from every receiver location, and so a method for culling the invisible images is required.

Jont B. Allen and David A. Berkley of Bell Laboratories refined the image model and applied the results to auralize speech.[39] At first, image models only applied to rectangular rooms. Jeffrey Borish developed a way of applying the image technique to more complicated shapes.[40] The heavy calculation demands of the image model slowed its acceptance. Heewon Lee and Byung-Ho Lee developed a more efficient algorithm[41] that helped to overcome this obstacle.

The ray-tracing and image techniques have remained the basis for computer modeling programs ever since. The ray-tracing approach is limited by the fact that rays spread apart as they progress, missing more and more reflections. The image approach is more calculation intensive, which limits the number of reflections that can be calculated. Theoretically, the two should give exactly the same results if you could have a hedgehog source with infinitely dense quills, or if you could calculate all possible images—except that ray tracing allows the modeling of scattering, which the images approach cannot.

In order to bridge the difference between the two approaches, the French acoustician Jean Paul Vian developed a variation on the ray tracing approach, using cones.[42] These cones fill in some of the gaps missed by two-dimensional sound-rays.

Another important refinement, foreshadowed by Schroeder *et al.,* was to add reverberation to the impulse response based on a statistical analysis of the room. This enabled programs to produce a realistic sounding impulse without having to calculate every single reflection.

FINITE ELEMENT AND BOUNDARY ELEMENT METHODS

Both the ray-tracing and images approaches are based on geometrical acoustics and share the limitation that they can only address the wave behavior of sound indirectly.

Two computational approaches that directly take the wave behavior of sound into account are finite element and boundary element methods, called FEM and BEM for short. The finite element approaches work by dividing up space into small cubes, the finite elements. The boundary element method does the same thing for the boundaries of the space. Within each cube (or square), the wave equation is solved, based on conditions at its borders. This only works if the elements are small compared to the size of the wavelength of the sound being studied. To keep the number of elements reasonable, these methods are restricted to low frequencies and small spaces. They are mostly used to analyze small spaces such as the interiors of ducts or car passenger volumes, rather than large rooms like concert halls.[43]

WAVE BEHAVIOR IN COMPUTER MODELS

Unlike physical scale models which model wave behavior as a matter of course, it is difficult for computer models to take into account the ability of sound waves to bend around objects (diffraction) or to scatter (diffusion). Currently, a great deal of research is focusing on incorporating such wave behavior into computer models. Researchers at Chalmers University have recently incorporated the bending of sound around edges (edge diffraction) into their computer auralization program. Their listening tests indicate that the inclusion of edge diffraction into the computer provides an audible improvement.[44]

Many current programs use a combination of approaches: for example, the images method for early reflections combined with a reverberant tail based on the shape of the early decay curve calculated by ray tracing. Methods to integrate diffusion and diffraction are being developed rapidly.

ROUND ROBIN

Do these programs work? How do they compare with each other? With real rooms? Which approach is superior, images or ray tracing? In 1991, Robert A. Metkameijer of Peutz & Associés in the Netherlands called

for a round-robin test of computer model programs.[45] In 1995, the round robin was held in Braunschweig, Germany, with 14 different programs.[46] Numerical room criteria calculated by these programs were compared with measurements from the actual hall (the PTB Auditorium in Braunschweig). The three programs that gave the most accurate results incorporated some calculation of sound diffusion, a good indication of the importance of this aspect of room acoustics modeling.

A second round robin was held in 1998. This time a larger concert hall (the Elmia Hall in Jönköping, Sweden) was modeled, and results were studied over a wider frequency range. Predictions were less accurate in the lower frequencies (125–250 Hz)—probably because of the limitations of geometrical acoustics.[47]

Ingolf Bork of the Physikalisch-Technische Bundesanstalt in Braunschweig, Germany, has called for a third round robin,[48] using a smaller room with more complicated geometry, and including auralization.

Auralization Revisited

Auralization brings acoustical modeling to life. The earliest auralizations by Spandöck were done directly, by playing scaled-up sound into model rooms, then listening to the results after slowing down the tape. This method was limited by noise and necessitated large models (1:10 scale).

Using digital signal processing, the impulse response of the scale model room can be used to model the sound of the full-size room by altering the sound of a "dry" recording (taken in an anechoic chamber). An anechoic chamber has (almost) no sound reflections. By recording a performer or speaker in an anechoic chamber, one obtains the sound of a performer essentially without a room. By modifying this performance with the impulse response of the scale model room, one can hear what this anechoic performance would have sounded like if it had been played in the room under consideration.

Why go to the bother of first measuring the impulse response and using it to manipulate a "dry" recording? Why not just speed up the recording and re-record it in the room, as Spandöck did? There are several reasons. Impulse responses can be measured with much less noise than recordings following Spandöck's method. Furthermore, it is easier to construct a spark source than a miniature loudspeaker that is capable of reproducing the full (speeded-up) bandwidth of the music. Finally, the impulse response method is very flexible, since a single impulse response measurement can be used to manipulate any kind of "dry" recording afterwards.[49]

Of course, there are many reasons why the modeled sound will not sound *exactly* like a performer in the real room, even assuming that the model mimics the real room perfectly. The directional characteristics of the performer differ from the directional characteristics of the model sound source (though very complicated radiation patterns can be modeled). Furthermore, a performer does not play the same way in an anechoic chamber as in a concert hall; performers react to the room in which they play. They move about when they play, which affects their sound audibly. Models are imperfect. They are only models, after all.

Physical scale models are still being used in acoustical investigations. In fact, nearly every important performance space is modeled before being built. Scale models are usually built by professional model builders and can cost over $10,000 for a 1:50 scale model of a large auditorium.[50] Model studies tend to flourish in universities where there is a steady supply of graduate students to build them. Dr. Mike Barron of the Department of Architecture, University of Bath (United Kingdom) and Dr. Gary Seibein of the University of Gainesville, Florida, have been involved with scale model studies for decades.

For larger concert halls, both extensive computer and scale modeling is standard practice. Unfortunately, it is difficult to justify the expense of building models for less prestigious projects. Moderate-sized dedicated spaces such as recital halls and drama theatres probably do not really require modeling, unless some out-of-the-ordinary approach is being tried out.

One very common project type, however, always requires computer modeling: sound systems in reverberant churches. Several computer modeling software packages are currently available that incorporate sound-system design: CADP2 by JBL, EASE, and CATTAcoustic are a few examples. These programs utilize a growing library of information about the directional characteristics of loudspeakers that manufacturers eagerly make available. They come with desktop auralization, allowing listeners to hear the results over headphones.

Figure 14 shows the use of EASE to choose and aim a loudspeaker cluster in a church sanctuary. Note the clear view of loudspeaker coverage, which can be studied at a wide range of frequencies. With this program it is possible to try out a wide variety of loudspeaker locations, orientation and models in a model room. One can also investigate the behavior of loudspeakers or groups of loudspeakers over the entire audible frequency range. This powerful design tool sure beats hanging loudspeakers in the space based on a single number indicating coverage and hoping they work out.

Figure 14

This technology, too, is following the familiar trajectory from the laboratory to the desktop.

Diffusion

In this section, I present a challenge for architects: diffusion. In every great old concert hall — Musikvereinssaal, Concertgebouw, Boston Symphony, Troy Savings Bank Music Hall — there is a profusion of architectural ornamentation: dentils, pilasters, pillars, capitals, coffers, flowers, and — my favorite, holding up the balcony of the Musikvereinssaal — golden caryatids, which is Greek for "statues of bare-breasted ladies." This ornamentation serves to break up sound, preventing discrete echoes, smoothing out standing waves,[51] and making for a pleasant, diffuse sound field. Hence the term "diffusion."

It is a commonplace belief among acousticians that diffusion is a good thing. It is simple enough to calculate reverberation times or noise levels, but diffusion is difficult to quantify. Dr. Peter D'Antonio is working on quantifying the sound-diffusing properties of materials and forms and developing a standard for diffusion.[52] D'Antonio also makes commercially available model versions of the full-sized sound-diffusing products sold by his firm, RPG Diffusors, Inc. An interesting aspect of D'Antonio's work is his attempt to provide sound-diffusing surfaces that work visually with a more modern visual sensibility.

C.H. Haan and F.R. Fricke[53] did a study in which they compared

diffusion to acoustical quality in a number of well-known concert halls. The amount of diffusion was determined by studying photos of these halls, and acoustical quality was assessed from questionnaires. A strong correlation was found between the amount of diffusion and acoustical quality.

However, as the authors themselves point out, halls that are designed with care will tend to have a lot of diffusion; so perhaps the amount of diffusion merely indicates that much attention was given to other aspects of acoustical design, which really determine the quality of the space. Based on my own experience and the experience of acousticians whose work I respect, I still believe that diffusion is a good thing, and the more the better.

The sort of architectural ornamentation that works so naturally in older buildings seems to be more difficult to pull off in newer ones. Although we seem to have emerged from the dark ages of the International Style, with its austere forms and clean lines (clean until the first good snowstorm), the current vernacular is still rather spare. Architects just do not seem entirely comfortable with ornamentation. A common approach to sound diffusion is to mount "diffuser panels" on the walls. These panels look tacked on because, well, they are tacked on.

There are aesthetic advantages to the sort of large-scale surface irregularities that work well for acoustics. They tie things together — recalling the restful complexity of nature — and they help a building to age gracefully. There is nothing uglier than some erstwhile pure monolith, thirty years later, with water lines running from its roof and cracks mucking up its perfect geometry. Greek temples, because of their ornamentation, look great even as ruins.

I see ornamentation returning. There is a new playfulness about recent architectural design. An early example of this return is Michael Graves' use of the Seven Dwarfs as caryatids for the Disney Office Building in Burbank, California. Yet more fanciful is the work of Frank Gehry, such as the masterful Guggenheim Museum in Bilbao. Gehry is working on the Walt Disney Concert Hall in Los Angeles. There are new materials available (such as fiberglass reinforced gypsum) that make the use of complex shapes more affordable than previously. This bodes well for acoustics. If form should follow function, then the interiors of listening spaces should be full of playful, complex, sound-diffusing forms.

Common Acoustical Myths

I enjoy myths about acoustics. After all, I named my firm after a mythological man, Orpheus. There seem to be two major categories of

acoustical myths: wishful thinking about noise control, and charming myths about concert halls. Concert halls get the best myths; here are a few of my favorites.

- Broken wine bottles under the stage are the secret to the great acoustics in old European halls.
- Some believe that the secret to the golden sound of the fabled Grosser Musikvereinssaal in Vienna (considered to be the greatest hall in the world for the romantic symphony orchestra) is the gold leaf cladding the bare breasted caryatids that support the balconies.
- The big dry well under the Academy of Music in Philadelphia is responsible for its wonderful acoustics.[54]

Since the Philadelphia Orchestra has built a superb new concert hall, it can now be publicly stated: the Academy of Music in Philadelphia is a beautiful, historic, charming building with wholly unsuitable acoustics for orchestra. The Philadelphia Orchestra achieved its renowned lush sound by compensating for the extremely dry and unsupportive acoustics of the Academy of Music. The dry, unreverberant acoustics results from the roughly 2,900 audience members[55] who completely surround the main volume of the auditorium, soaking up sound as they sit. The location of the orchestra in a separate stage house further isolates the audience from the sound of the orchestra. The large dry well under the Academy doesn't influence the acoustics inside the hall any more than does the lobby outside the hall or carpet in the building next door.

Occasionally, people believe something correct, for the wrong reasons. I was sitting in Carnegie Hall one evening and overheard someone saying that the sound up in the balcony was better because sound rises, like heat. I like that. The sound *is* very good in the balcony at Carnegie because these seats are in the main volume of the space and because the entire ceiling is available for sound reflections. In the front of the balcony, one hears sound that has not been attenuated by grazing over the audience, which steals low-frequency sound through a complex process of selective interference. Also, many instruments radiate sound upward: some directly, like the violins and the oboe and clarinet (through the keyholes), and some indirectly, like the oboe and clarinet bouncing sound off the stage floor. The stage floor is also seen at a steeper angle from on high, making it effectively larger for sound reflections. Perhaps the lady was right after all. Sound from an orchestra does rise, not exactly like heat — but rise it does.

PERFECT ACOUSTICS

"Perfect acoustics" is a myth. Like the Greek sea-god Proteus, who could change his shape at will, there is no single "perfect acoustics"; acoustics is multi-dimensional. A room cannot have perfect acoustics, though it may have acoustics eminently suitable for a particular function. Boston Symphony Hall may be superb, excellent, "perfect" for romantic symphonies, but not so great for watching a film.

The ancient Greeks designed outdoor theatres with remarkable acoustics. At the very rear of the 6,400-seat amphitheater at Epidauros one can hear a small coin dropped onto the stage. The remarkable clarity in these ancient theatres has led to the belief that their acoustics are perfect and due to some lost secret. The Greeks themselves had some interesting ideas about the acoustics of these theatres. Vitruvius advocated placing "sounding vessels" in strategic locations throughout the theatre.[56] What he describes are Helmholtz resonators which, like open Coke® bottles, will resonate and absorb their resonant frequency. A moment's reflection will reveal that the sound absorbing capabilities of these bottles would be absolutely trivial compared with the vast sky overhead.

The reasons for the acoustical clarity in these theatres are straightforward: no reverberation, very steep seating, a helpful sound-reflection from the stone surface in front of the stage, and virtually no background noise. These are close to ideal conditions for understanding speech, but are unsatisfactory for musical performance. In fact at the ancient theater in Caesarea, Israel, a large orchestra shell has been constructed to make the open-air theatre suitable for orchestral concerts by providing a *room* (albeit one that is open to the open-air audience chamber). The shell is designed so that it can be moved laterally out of sight of visitors to the archeological site.[57]

Vitruvius had a very clear idea of how early reflections can support speech and how late reflections can interfere with speech. Discussing several ways in which the voice can sound in a theatre, he states: "The resonant are those in which it [sound] comes into contact with some solid substance and recoils, thus producing an echo, and making the terminations of cases sound double. The consonant are those in which it is supported from below, increases as it goes up, and reaches the ears in words which are distinct and clear in tone."[58] He is describing late and early sound reflections.

The Mormon Tabernacle in Salt Lake City is a remarkable building. It was constructed without any nails and held together by wooden pins and tied together with strips of buffalo hide.[59] None of this has anything at all to do with the fact that at one location you can hear, perfectly clearly,

sound produced in another location. This effect occurs because the form is an elliptical volume. Sound is focused between any two foci of the ellipse. Standing at one focus, one can hear a sound produced in the other focus with clarity that is surprising, given the distance. This is certainly not perfect acoustics, but rather an unintended focusing effect due to geometry.

Another variation of the perfect acoustics myth is the idea that perfect acoustics is achieved by engineering the perfect reverberation time: 1.873 seconds is just right; 1.904 is too much; 1.754 seconds is terrible. The focus on reverberation time as *the* index of acoustical quality reminds me of the story of the drunk looking for his house keys under a nearby street light — when he had obviously lost them somewhere near his darkened front door. When asked why he is searching in that particular location, he replies "this is where the light is." We tend to look for answers where it is convenient to ask the question. There is a lot more to excellent acoustics than finding the precise reverberation time. In fact, the very best modern halls have adjustable reverberation.

There is also the idea that great acoustics results from precise mathematical proportions among the dimensions of a room. Like many myths, there is a grain of truth here. The *scale* of a room is fundamentally important; and extreme proportions will result in poor acoustics. A hall that is too long will place audience members too far away in the back of the hall. A hall that is too wide will lack the important sound reflections from side walls. But precise mathematical proportions are irrelevant to concert hall acoustics.

Room proportions are important for small rooms like recording studios, on the other hand. The lengths and proportions of such rooms will determine which room modes will resonate. In such rooms, overly pronounced room modes require compensation. However, the acoustical requirements for such small rooms are very different from concert halls.

The flip side of the "perfect acoustics" misconception is the idea that a particular space has acoustics so bad that it is utterly hopeless. I heard this opinion stated for years about a hall at a nearby college that was eventually renovated into a really lovely recital hall. The basic scale and construction of this space were fine, as revealed by the renovation. Previous to the renovation, however, people talked about the acoustics as if the location itself was acoustically cursed. This idea goes way back. Vitruvius states: "There are some places from which from their very nature interfere with the course of the voice...."[60]

ABSORPTION IMPROVES SOUND-BLOCKING

It is quite commonly believed that placing sound-absorbing material on a wall will reduce sound transmission through that wall. Though based

on a misunderstanding of how sound works, this idea, too, has a grain of truth in it. Sound-absorbing material in a room where sound is being produced will reduce the overall level of sound in that room. This can help in rooms that have very little sound-absorbing material to start with. Even when used extensively, there is a limit to how much sound can be reduced with absorption. Sound-absorbing material only absorbs sound that has built up due to reverberation in a room. It is no help whatsoever in blocking sound. This is because sound must pass through material in order to be absorbed.

Sound-absorbing material can be so effective in curing the build-up of sound in "live" rooms that it is sometimes taken to be a panacea for all acoustical ills: thus the term "acoustical material." *All* materials are acoustical because all reflect, absorb and scatter sound to some degree. The process of absorbing sound is entirely passive, so one cannot "suck" sound out of a room with special "acoustical" materials.

CERTAIN MATERIALS HAVE A MIRACULOUS EFFICACY

Miraculous acoustical properties are sometimes ascribed to certain materials, egg crates and Homosote® being two examples. Egg crates do absorb some sound. However, they are highly flammable. For sound absorption, fiberglass panels or open-pore foams work best.

Homosote® is a building product made out of recycled paper. It is very useful in helping dampen vibration through floors. It is no more effective in blocking sound through walls than any other material of similar density and stiffness, and it is only a very modest sound absorber. Lead sheeting is the closest thing to a miracle material for blocking sound. Limp and dense, lead is the sound-blocking material par excellence. Unfortunately, lead is very difficult to work with; it rips easily, and is toxic. There are some limp barrier materials on the market now, made of mineral-loaded vinyl, that work as well, or better than lead.

Concrete is bad. Like all materials, concrete both absorbs and reflects sound. Concrete is a wonderfully useful construction material, the most widely used construction material in the world. Many performance and worship spaces are constructed out of concrete. When painted, concrete reflects nearly all the sound that hits it, which may or may not be what you are looking for in a particular application. When concrete is left unpainted, or merely stained, it is moderately sound absorptive. I often recommend stained concrete for the construction of gymnasiums or fellowship halls for its mildly sound-absorbing property. Concrete is a wonderful, extraordinarily useful material.

The idea that concrete is bad acoustically probably comes from the

fact that it is an inexpensive material. Buildings constructed of concrete may well have other corners cut with their acoustics, for example placing mechanical equipment directly on the roof. Since the concrete is visible, it gets all the blame for lots of other faults.

There was a big scandal when concrete was discovered under the stage at Carnegie Hall.[61] This was an inappropriate use of this material, because it interfered with the function of the stage floor as a radiator for the sound of low-frequency instruments like 'cello and bass. However, it would have been equally inappropriate to cover Carnegie Hall's plaster walls with wood.

Wood is good. Wood is often proposed as a material promoting perfect acoustics. It was believed to be responsible for "singing tone"[62] and was regularly included in the design of halls early in the 20th century. Although wood has no magical acoustical powers, I often recommend that it be used in the design of halls for music because its visual association with the violin family gives it tremendous psychological powers.

A concert hall is not a violin, however. The walls of a violin must flex to radiate sound out of the body of the instrument into the surrounding air. The walls of a concert hall must contain sound for listeners inside. Wood paneling that is free to flex can absorb low-frequency sound and detract from the warm sound of a concert hall. That is why when using wood in concert hall design, it should be used sparingly, and it should be constructed to act as much as possible like concrete by being bonded to more massive materials, rather than attached with an air space. The exception is the stage floor, which does act as a sound radiator for the bass instruments.

Acoustics is susceptible to misunderstanding because sound is not visible. Furthermore, mistaken beliefs about sound arise from the human desire for convenience and easy solutions. Wouldn't it be nice if there were such a thing as "perfect acoustics" that could be achieved by hanging something on a wall?

The Myth of Orpheus and Eurydice

The word "myth" has two meanings. It can mean "mistaken belief" as I have used it in the previous section. It can also mean "a story, not literally true, that reveals truth." With the later definition in mind, I named my firm Orpheus Acoustics after the mythical figure Orpheus, the first mortal musician in Greek myth.

In ancient times there lived a man named Orpheus. The first mortal musician, his voice and lyre were so sweet, so compelling, that savage

beasts would sit and birds would still their voices to hear his song. One day Orpheus met Eurydice, a maiden whose gentle beauty and good heart were as lovely as his music. They fell in love. The wedding was attended by all the folk from miles around, for both Orpheus and Eurydice were well loved by all who knew them. After the wedding feast, walking hand in hand towards their new home, Eurydice trod on an asp. The bite was so venomous that she died as she fell.

Orpheus was overwhelmed with grief and anger. He determined to bring his beloved bride back from her untimely death. He would descend to the Underworld to get her from Hades himself. After a long and frantic search, he finally found the secret entrance to the kingdom of shadows. He entered, boldly but carefully, playing his lyre as he went to soothe the savage spirits into whose domain he was trespassing.

To enter the kingdom of the dead, he had to cross over the dreaded river Styx, whose waters no mortal had ever crossed to return again. On the bank stood the one-eyed boatman Charon, who demanded his customary penny for the trip across. As he rowed across the waters, Charon's one eye brimmed with tears from Orpheus' song. When they reached the other shore, Charon wished him well with his entreaties to the dreaded Prince of the Underworld. Orpheus continued on. When he reached the gates of Hades, Cerberus, the three-headed guard dog, lay down and let him pass. As he walked and played, the spirits on either side of his path paused to listen. Their eyes glistened with deathly tears. His song reminded them of the sweetness of life and the brevity of youth.

Sisyphus paused in his frustrating labors and Tantalus forgot his racking thirst for a moment to listen. When Orpheus reached the throne of Hades and Persephone, the King and Queen of the Underworld, he began his song of entreaty for the return of Eurydice. He wept, he sang, he played his lyre, pouring out his grief and love and longing through his song. Hades and Persephone were both moved to tears. Persephone begged her husband to allow Eurydice to return.

At last, Hades relented. "Eurydice may return to the world of the living," he said, "but under one condition: you may not say a word to her, you may not turn, you may not see her until you have left my realm to stand under the sky." Orpheus immediately agreed and began his journey back to the light, with Eurydice walking, silent as a shadow, behind him. He began his journey in hope, but as they walked, doubt started to gnaw at his breast. "What if it is all a grim joke?" He couldn't hear her, he couldn't even catch a glimpse of her shadow through the long, lonely journey.

At long last, he saw a glimmer of light in the distance. "Eurydice," he cried "I see a light." But she could not reply. Without thinking, he turned

to speak to her again. And in that brief, final moment he saw her falling back, arms reaching out to him, back into the eternal shadows, forever.

Orpheus, overwhelmed with grief and self-recrimination, went mad. From that day on, he wandered through the world playing and singing songs of utter desolation. Vast reaches of the forest fell silent under his musical spell.

One day, Orpheus wandered into a band of carousing wood nymphs. Crazed by their revels, they were deaf to his song. Falling upon the hapless Orpheus, they tore him to pieces. They ripped his head from his body and threw it into a nearby stream, where it continued to sing, more sweetly than ever, as he drifted down into the Underworld to join his beloved Eurydice.

3. Acoustical Design

Dialogue

> Bid me discourse, I will enchant thine ear.
> — William Shakespeare

Perhaps all "critical listening spaces" are rooms for dialogue. "Dialogue" comes from the Greek: "dia" meaning "between, or among" and "logos," which means "word." But logos can also mean "the word by which a thought is expressed," or even "the inner thought itself." Logos is a weighty term. The Stoics used it to mean the central guiding idea of the universe. Christians apply the term to Jesus Christ, as this central guiding idea made flesh. Clearly, logos is deeper than the English word.

Perhaps a good definition of dialogue would be "the exchange of words or ideas." But not every exchange of words should be dignified by the term "dialogue." The ideas being exchanged must have some depth or importance to warrant the term. Idle chitchat or gossip is not dialogue.

Some thoughts cannot be expressed in words. Yet I believe that their exchange can also be considered dialogue. Can a pantomime be dialogue? I think so. I know that dialogue is central to music: amongst the musicians in an ensemble, between musicians and audience, and even between the composer and performing musician. But how can this be? After all, the composer may be dead, or otherwise unavailable for comment. Let me explain. When a musician prepares a piece from the score, there is a continuing dialogue with the composer.

This sort of process goes on with all great art. The honest director asks William Shakespeare how to put on his plays. He asks by careful reading,

and if he reads carefully enough, Shakespeare will answer his questions. Each time we read a great poem or listen to a great piece of music, we come to it with a different state of mind, ask it different questions, and it answers differently. This creates an ongoing dialogue.

This gives us a way to distinguish between art and entertainment. (I use the term "art" here in the broad sense, encompassing music, poetry, drama, dance, painting, sculpture, and architecture.) It may not always be easy to make this distinction, but there is a distinction to be made nonetheless.

Entertainment entertains. It does something to the passive recipient. The interaction is unidirectional, rather than an active dialogue. There is nothing wrong with entertainment (in moderation). It may even be necessary. But it is not art. Art engages its audience in dialogue. Art is sometimes (often? usually?) used as entertainment. One might play a recording of a late Beethoven string quartet (the very highest art) while preparing dinner. It is not Beethoven's fault that his lofty discourse is being used as background while chopping the onions.

Conversely, works that were intended for entertainment may turn out, in the end, to be art. Some of the best art served originally as entertainment. Shakespeare was a popular entertainer — though he knew just how good he was. People are beginning to ascribe the term "art" to the best of the Tin Pan Alley popular songs of the thirties and forties, like Jerome Kern's "Old Man River," or "All the Things You Are."

Does it engage you in dialogue? Can it engage you in dialogue? Then it is art. Am I encouraging people to start talking to buildings? ("What a nice facade you have." "I adore your new shingles.") The function of architectural acoustics is to support and encourage audible dialogue.

Acoustics for Chamber Music

Often in chamber music, the only audience members are the performers. In this case, nearly any living room with a modest to low noise level and a little breathing room for sound will suffice. But for public performance, the criteria ought to be stricter.

Chamber music lovers are a strange lot. We get all bent out of shape at noises that wouldn't even be audible in most other situations. Imagine someone slowly unwrapping a candy wrapper at a hockey game — no problem! Such noise, however, is not acceptable in a chamber music hall. The ideal background noise level is the threshold of human hearing.

Chamber music halls should be modest in size. There are wonderful

concert halls—Carnegie comes to mind—that are simply too large for truly excellent chamber music acoustics. What exactly is too large for chamber music? That depends on the geometry of the hall and the nature of the performers. Often, well-known groups must play in oversized halls in order to cover their fees. But occasionally one will hear a group play in a room which is too small to contain its powerful sound. I remember hearing the Guarnieri Quartet in the Tawes Recital Hall at the University of Maryland. This intimate hall is perfect in scale for student chamber groups, but these professionals sounded like a symphony orchestra in there. Even powerful groups like the Guarnieri, however, need to be able to exploit the softer end of the dynamic scale; quiet background and less-than-symphonic size will allow them to be heard to best advantage.

A hall with balconies will be more intimate than a hall with the same number of seats all on the same level. Furthermore, modern seating codes and larger modern human bodies mean that modern halls have to be larger than older ones to contain the same number of seats.

Many chamber music performances take place in multipurpose theatres such as school auditoriums. Chamber music is rarely served well by these spaces. As the name implies, chamber music performers should play in the same chamber as their listeners, rather than in a stagehouse, which acts like a separate room. Stagehouses surround the performers with curtains that absorb much of their sound before it gets anywhere near the audience. Chamber music performers need hard surfaces nearby for ensemble and to preserve their sound, so that the audience receives as much as possible.

When performing in a stagehouse, a stage shell can help — somewhat. Stage shells are a sort of artificial wall that provides hard, sound-reflecting surfaces for musical performers in a stagehouse. Shells can be moved off stage or flown into the flies for drama. There are some excellent products on the market, and there are also some flimsy shells that do little more than shift sound absorption down into the bass region. In the best chamber music halls, however, no separate shell is necessary, since the stage is in the same space as the audience. Some people think that stage shells actually throw the sound out. This is not the case. These devices are entirely passive. They are a poor substitute for a solid masonry wall.

The pattern of sound reflections, which creates the acoustics of a room, results from the room's geometry. A wide, fan-shaped space, for example, tends to focus these sound reflections towards the back of the hall, leaving the audience members in the middle seats starved for sound reflections. The great chamber music spaces are all rectangular in plan. Balconies on the side are also positive, though many chamber music halls

are too small for them. Side balconies serve two essential functions: they bring people closer to the action; and their undersides send sound reflections down to audience members below.

Acoustics is not the only aspect of a room that makes for a wonderful evening of chamber music. There is also that elusive quality, ambiance. Wooden walls, for example, have no positive acoustical value whatsoever. Yet both audiences and performers love its look and feel so much that many halls are covered — at great expense — with wood. Plaster or concrete is usually a better choice since these materials are denser and thus do not absorb low frequencies as panels do. The best halls, for the most part, have walls of plaster. But for ambiance, wood takes the prize. I often recommend that wood be used as trim with plaster walls.

Audiences are often happy to trade acoustics for ambiance. The outdoors are far from ideal for listening. Even in the most idyllic setting, bugs make a racket. But nothing beats the ambiance of a chamber music concert in the woods. On the other hand, great acoustics contributes to ambiance. The warm buzz of the audience before a concert in a great hall is a perfect aperitif for the delights to come.

Many of the rooms where we listen to chamber music are far from ideal, acoustically. They are too often dead, noisy, and immense. It used to be that nearly any live performance was an improvement over a recorded performance. No longer. Certainly, there is something magical about the mere fact that a performance is live. But is this enough? To someone used to hearing the quartet of his dreams at any volume he chooses in a quiet, suburban house with state-of-the-art equipment, a live performance in a hall with mediocre acoustics is likely to be disappointing.

If live chamber music is to thrive, it must compete successfully with the electronic experience. Hearing a great ensemble in a great hall can be almost overwhelming; one feels totally enveloped in beautiful sound. Acoustics is an integral and necessary part of the art of chamber music.

Synagogue Acoustics

Shema Yisroel Listen, Israel
Adonoy Elohenu The Lord (is) our God
Adonoy Ehad The Lord is One

The Shema is the central prayer in the Jewish liturgy. It is affixed to the doorpost of every Jewish home and recited by observant Jews before sleep every night. An affirmation of the oneness of God, the text strongly

implies that acoustics is fundamentally important to the design of synagogues. But what sort of acoustics? Generally speaking, a room intended for music should be very reverberant. A room intended for speech should be relatively "dry." But what about a room for chanted prayer? To answer this question, we must look beyond the useful, but narrow, concept of reverberation.

What do we want to hear in a synagogue? Prayer is both spoken and sung by the congregation and by the prayer leader; the Torah is chanted in Hebrew; sermons and announcements are spoken in the vernacular. What are the acoustical requirements for these various functions, and what do they imply for the architecture?

Congregational singing and prayer require a certain amount of acoustical feedback: sound reflecting back to the worshipers from nearby hard surfaces, which helps to create a "singing in the shower" effect. Sound-reflecting surfaces such as floors and pew-backs help create this effect, without which one feels as if one is praying in isolation.

In an Orthodox synagogue, or one designed on the Orthodox model, the cantor chants with his back to the congregation. In all synagogues, there are portions of the service when the prayer leader faces the Ark, away from the congregation. Without hard surfaces to reflect sound back to the congregation, his voice will sound weak and indistinct. In addition, he needs the support of sound coming back to his ears; otherwise he may push and strain his voice. This can be a real problem on Yom Kippur, when no water has passed his lips all day.

One must be careful with reverberation within a synagogue, however. Too little sound-absorbing surface area, or too high a ceiling, will make for an overly reverberant space that will undermine speech intelligibility, a very high priority, especially for sermons and announcements in English. On the other hand, the musical quality of sound of the service is also important.[1] To my ear, this calls for a certain amount of reverberation. A delicate balance must be struck in the architectural acoustics, as it is in the liturgy.

The layening (chanting) of the Torah is a brilliant method of clearly presenting information in a beautiful package. Speech intelligibility is extremely important in reading the Torah. However, mere information is not enough; this information should be presented in a pleasing manner. The chanting of the Torah transcends decoration; it also aids intelligibility of the text. By slowing down the pace of the words and by exaggerating the pitch range, chanting allows for — even takes advantage of — reverberation to enhance both the intelligibility and the beauty of the text.

In an Orthodox synagogue, women sit separately from the men. Often

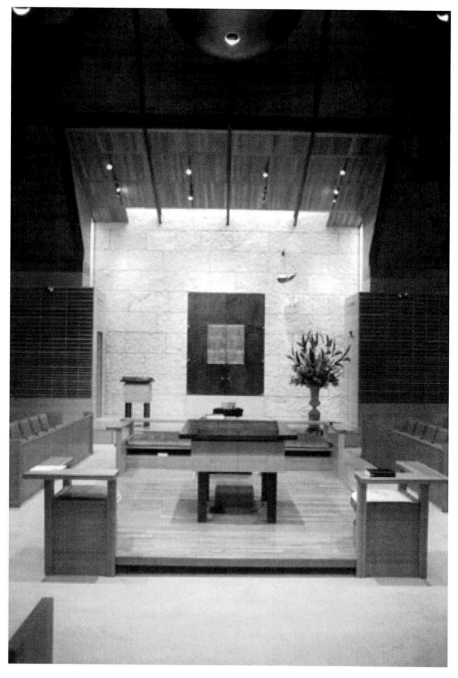

Figure 15. Inside a modern synagogue. Photo by Lake/Flato.

there is a barrier (a mechiza) between the men's section and women's section. Since the women often sit to the side, or to the back, and since they do not participate directly in the service, it is imperative that they have the best possible conditions for hearing and seeing. I believe that they should have *better* sightlines than the men. In particular, the mechiza should be designed so that it interferes as little as possible with the hearing and seeing. Any solid material, such as glass, should be avoided, since it will block sound.

Elevating the women's section accomplishes two desirable goals: It makes the women's section less visible to the men below; and it offers superior conditions for hearing and seeing to the women. If the design of the women's section is handled properly, men and women can be separated without slighting the women by impeding their ability to hear and see the service.

In an Orthodox synagogue, amplified sound is not permitted on the Sabbath. A microphone works by transforming sound into an electrical current (or by modulating a small electrical current). This is considered to be the equivalent of kindling a fire, which is a type of work forbidden on the Sabbath.

Sound systems are permissible and common in Reform and Conservative synagogues, though some congregations will avoid turning the system on and off during the Sabbath. Though larger sanctuaries may require a sound system, I believe smaller congregations should consider not using sound systems on the Sabbath. Amplified sound does violence to the tranquil spirit of the Sabbath. Sound systems distort the sound of the human voice; they introduce a barrier between speaker and listener; they encourage poor speaking habits; and they discourage courtesy and attention. In a synagogue, we are there to study and pray together, not to be yelled at by someone with a louder, amplified voice. In my experience, sound systems are often more of a hindrance than a help to speech intelligibility.

Synagogues are not churches. A typical church requires a sound system for speech intelligibility in the reverberant acoustics necessary for organ and choir; and the contemporary amplified church bases its whole liturgy around the sound system. The Reformed temple is modeled on the Protestant church, with choir and organ, so perhaps this hybrid can be considered a traditional Protestant church, from an acoustical point of view.

As discussed earlier, strict noise control is the most important aspect of good acoustical design for speech intelligibility. People occasionally point out to me that there tends to be a lot of talking during the services in Orthodox synagogues. This is not a reason for allowing higher background noise levels. Rather, lower background noise levels will encourage lower audience noise levels.

In many synagogues, there is additional space that can be opened to the sanctuary on occasions such as the High Holy Days. These spaces are often closed off with a movable partition. These partitions are never perfect noise barriers. However, people in the additional space may not realize that they can be heard in the sanctuary, even though it appears to be closed off. It is worthwhile, therefore, to use a partition with a high noise rating. Correct installation is critical, since even a small gap can severely compromise noise isolation.

The acoustical conditions in the additional space when it is open during High Holy Days are often not ideal. The seats are more distant from the ark, often with no additional elevation to compensate for this distance. Designing these spaces for optimal acoustics entails expenses. Is this worthwhile for only a few services during the year? Even if these are the most important services of the year? At the very least, mechanical system noise ought to be minimized in these spaces. An additional step to improve acoustics would be to elevate these more distant seats.

Any synagogue will likely have a number of members with impaired hearing. These people fall into two groups: those whose hearing is starting to decline, but who do not use a hearing aid; and those with hearing aids. Fortunately, conditions that improve speech intelligibility for those with normal hearing — low background noise, strong early sound reflections, and relatively low reverberation — will also help those who are hard-of-hearing. Background noise levels below the hearing threshold for hard-of-hearing listeners will encourage others to curtail extraneous noise, thus improving matters for the hard-of-hearing.

Hard-of-hearing individuals have a much lower tolerance for reverberation than do those with normal hearing. I do not believe, however, that sanctuaries should be designed to be extraordinarily non-reverberant. A certain amount of reverberation is beneficial, as we have discussed. The proper balance is best worked out for each individual congregation.

Another aid to the hard-of-hearing is to provide seating from which it is easy to see as well as hear people speaking from the bima (front platform). Hearing assistance systems amplify sound just to the people that need it. Some of these broadcast directly into hearings, others use headphones. It is entirely possible to use these systems without amplifying sound within the room. In fact, no amplification in the room ought to make these systems function better. Such a targeted approach is much better than the common one of setting the level of the sound system for the sanctuary at a volume required by the person in the congregation with the worst hearing.

Degel Israel

Let us consider an example of a synagogue that is considered to be acoustically successful, both by its congregation and by several professional acousticians: Degal Israel of Lancaster, Pennsylvania.[2]

The sanctuary is a simple, rectangular box of modest scale. It is 42 feet wide; the farthest rear seat is only 44 feet back from the bima. The ceiling, at 21 feet, is high enough for a little acoustical "breathing room," but low enough so that sound reflections off the ceiling arrive early enough to support, rather than mask, voices coming from the front.

One would call this room neither reverberant nor "dry."[3] It has enough reverberation so that the shofar (ram's horn sounded on the High Holy Days) can resound a bit; the sound of the congregation blends pleasantly in prayer; and words from the bima are supported by the room, yet not covered up by reverberation. This is due to the room's dimensions and to a judicious blend of hard and soft surfaces. The wall behind the bima, for example, is a large area of hard wood. This surface, along with the plaster wall and ceiling, serves to reflect sound from the bima out to the congregation. This is especially important when the cantor is chanting with his back to the congregation. (Note: further improvement could be had here by removing the carpet from the bima.)

The backs of the pews are hard, providing some acoustical support for worshipers and allowing them to blend with their neighbors. Thick carpet in the aisles, on the other hand, cuts down on the buildup of later sound reflections, which would tend to obscure speech.

There is room for improvement here, mainly in the area of noise control, but a lot of the elements we have dealt with in this volume are just right.

Upon reflection, perhaps acoustics is not the sovereign concern in synagogue architecture. A synagogue is neither a concert hall nor a lecture hall; it is a house of prayer and study. Much of what goes on is known by heart by many of the congregants or can be read out of the prayerbook or Bible. However, a pleasant sound and good speech intelligibility are blessings that will make the experience of the worship service more enjoyable and create a precious opportunity to hear the human voice partaking in that most human activity, prayer.

Church Acoustics

As an acoustician, I spend a lot of time listening in church sanctuaries. These sanctuaries—especially recent designs—are often disappointing acoustically (with a few exceptional pleasant surprises). This may

sound harsh, but it is unfortunately true. Churches fail acoustically for a
very simple reason. Acoustics is rarely considered a fundamental aspect of
design, but rather something to be tacked on later (perhaps after con-
struction).

Four items comprise the foundations for the acoustics of a church
sanctuary:

- isolation from noise;
- room shaping;
- sturdy construction; and
- integration of sound-system design into the room.

These must be considered during the earliest stages of design, while
the budget is still fluid and trade-offs still possible.

Why is it so difficult to achieve excellent acoustics in churches? The
answer, briefly, is that in such spaces both music and speech are impor-
tant, yet their acoustical requirements conflict. A church is a concert hall
and a lecture hall in one room at the same time. Church music (organs,
choirs, and congregational singing) sounds wonderful in very "live" or rever-
berant acoustics—the more reverberant, the better. Speech, on the other
hand, can be quite difficult to understand in such reverberant acoustics—
though not necessarily, as we shall see.

In some churches, the contemporary service with electronically
amplified music has replaced the traditional organ and choir. In a tradi-
tional church, the reverberant acoustics serve to amplify the music—a
function taken over by electronic systems in the contemporary service. To
put it simply, these electronic systems do not get along very well with the
natural amplification of a "live" room. They work best in "dead" rooms.

Thus, there are two approaches to the acoustics of a church: the "live"
room approach and the "dead" room approach. Older Catholic churches,
for instance, tend to be very "live" rooms; modern evangelical churches
tend to be acoustically "dead." The traditional Protestant church falls
somewhere in between, leaning towards the "live" end in older masonry
buildings. Each approach has its advantages and disadvantages.

What does one do, however, when the same sanctuary is alternately
used for traditional and contemporary services?

The "dead" room approach is surely the more convenient of the two.
In this approach, the room is filled with lots of sound-absorbing mater-
ial: thick carpet, cushions on the pews, sound-absorbing ceiling tile, sound-
absorbing panels on the walls. A very powerful, up-to-date sound system
amplifies everything: the choir, the piano, the preacher, the guitar, drums,

bass, singers. The congregation is usually not amplified. The shape of such a room only becomes an issue if it creates problems for the sound system. With a properly designed system, speech is clearly understandable.

There are some practical disadvantages to the "dead" room approach: sound-absorbing materials are nowhere near as robust as stone; and there needs to be a much larger investment in sound systems, which need periodic repair, adjustment and replacement. Also, in a nonreverberant space, one has to be more careful with echoes. A common problem in these rooms is flutter echo[4] due to sound absorbing floor and ceiling and concrete block or gypsumboard walls. Even in the most padded room, sound levels can get way out of control, causing problems with feedback and other forms of distortion. Often the drums set the volume level in the room.

Better, cleaner results can be achieved if amplified sound levels are limited. Although mechanical system noise control is less critical than in a traditional church, lower background noise means that less gain is needed from the sound system, which is a tremendous help in sound system performance.

In the traditional church, the "live" acoustics of the room are part of the worship experience. The celestial sound of the organ in the traditional church fills the space; one feels as if surrounded by sound. When the congregation sings, the voices blend into one voice. One no longer sings alone, but rather as part of a larger, single entity. Since the sound comes from many different directions and kinds of sources— organ pipes, vocal cords and mouths of all shapes and sizes— the sound has a natural richness and warmth that cannot be duplicated electronically. At its best, the experience of sound in such a space is heavenly.

The main disadvantage to the "live" approach is difficulty with understanding speech. Many traditional "live" churches approach the problem of understanding speech by merely installing electronic equipment, the acoustics of the space being more or less grudgingly taken into account (depending on the sophistication of the sound system designer). Many sound system designers consider "live" acoustics to be bad acoustics. The result is often too loud, too "boomy," very artificial sounding speech amplification — within a space that is doing plenty of natural amplification all by itself. However, this does not have to be the case.

How does one make speech intelligible in a reverberant space? First, one has to understand and embrace the benefits of reverberation for organ, for congregational singing, and for sacred ambiance. If speech intelligibility through a sound system is the only concern, the "dead" room approach is superior. In a "live" room, it is more difficult to achieve the kind of "hi fi" speech clarity that you get from the high fidelity equipment in your living

room. Reverberation will always, to a certain extent, detract from speech intelligibility. If, on the other hand, one wants to be able to understand speech in a reverberant environment, then one has a difficult — but solvable — problem.

Strict noise control is a big part of the solution. Normal hearing is so sensitive that, in sufficient quiet, molecules can be heard impinging on the eardrums. Thus, background noise determines to a large degree what is audible. Most new and renovated church designs allow excessive background noise from fans, organ blowers, heating and ventilation systems, and traffic. In a reverberant space, this builds up into a haze of noise, unnoticed by the untrained ear, but obscuring the understanding of speech. Suppressing background noise allows for much more reverberation before reverberation begins to interfere with speech.

Once background noise is taken care of, sound reflections must be managed so that sufficient sound energy arrives at the ear early enough to support rather than obscure speech. In a new design, this can be done by careful design of sound reflecting surfaces to reflect sound very quickly to the listeners' ears. In many renovations, such an architectural approach may not be possible. However, with subtle sound system design, appropriate choice and location of loudspeakers, adjustment of levels, equalization, and electronic signal delays, a sound system can work with the space, giving a clear and natural quality to speech. These days, with computer modeling of loudspeaker coverage and sophisticated measurement, there is no need to eviscerate the acoustics of a room just to satisfy the sound system.

A modest-sized sanctuary makes it much easier to balance the requirements of speech and music. A properly designed sanctuary seating 300 should be able to provide support for singing and (small) organ, with no difficulty hearing unamplified speech. A 2,000-seat sanctuary is a much more difficult problem.

Another issue, rarely addressed, is the manner in which one speaks from the pulpit. Because a sound system in a reverberant space must be more subtly designed than one in a "dead" space, the speaker must work with the acoustics of the space, speaking clearly and distinctly to the congregation rather than expecting the sound system to do it all.

Room Shape

The form of a space determines the nature of the sound field within. A twenty foot high ceiling, for instance, limits the reverberation necessary for organ or choir; a fan shape will send sound to the back wall, creating

what are called "slap echoes"; and a circular or conical shape will create focusing, echoes, and other entertaining acoustical effects. Barrel-shaped ceilings can produce odd "whispering gallery" effects and flutter echo. Proper room shaping can help (or hinder) the inherently difficult acoustical task of providing for both speech and music. A few panels on the walls will *not* compensate for a poorly shaped room. The best room shape for acoustics is not necessarily the most expensive. Interesting, curvilinear shapes can cause problems if their acoustical effect is not planned.

Recently, it has become fashionable to orient sanctuaries so that they are wider than they are long. This fad flies in the face of the experience of centuries of worship space design. I am at a complete loss as to why it has become so common. I am told that it brings people closer and makes the congregation feel more intimate. Nonsense. First of all, I have observed that when there are not enough people to fill a sanctuary, the empty seats are inevitable in the front, rather than in the rear. People don't necessarily want to sit closer. Amplification makes sitting up front even less necessary.

Figure 16

Figure 16 illustrates two alternative orientations of the same rectangular plan superimposed, with a dashed outline of the directionality of a human speaker on the platform. Three areas are indicated: **A, B, C.**

- A is shared by both orientations; there is no difference in distance or orientation to the speaker.
- Area **B**, the additional area gained by the wide/short orientation is way off to the side. These are not very good seats.
- Area **C** includes some seats within the dotted line of directionality that are included in the long/narrow orientation, but excluded from the wide/short configuration. Even the farthest seats at least have the virtue of facing directly forward towards the platform.

There are many advantages to the long/narrow orientation. As illustrated in, the human voice and the visual cues provided by face and gesture are directional. The long/narrow orientation takes advantage of this fact. A speaker directing his attention towards listeners off to the side in section **B** turns his back on those in the opposite section **B**. In an intimate space like Shakespeare's Globe theatre, this is not a problem, but it is a real barrier to communication in a larger space. Loudspeakers can deal with the vocal aspect of this problem, but do not address the fact that it is harder to understand someone without seeing his face and gestures.

The long/narrow orientation is easier to cover with fewer loudspeakers. To cover the wide/short configuration often requires a cluster of loudspeakers. This increases costs for a reduced benefit. More loudspeakers actually *reduce* speech intelligibility because they interfere with each other and because they create a sort of artificial reverberation.

The long/narrow orientation creates a smaller rear wall. Sound reflections from the rear wall back to the microphone or audience members can interfere with speech intelligibility or cause feedback. The wide/short orientation brings the rear wall closer, which means that rear wall sound reflections will be louder and more problematic. One popular approach curves this longer rear (or creates segments that act like a single curve), which further exacerbates the rear wall echo problem.

The short rear wall that results from the long/narrow configuration requires consideration, but is a more tractable problem.

The long/narrow orientation provides side walls that are close enough together to create an acoustical benefit. Sound reflection from these relatively narrow walls will benefit the musical program in the hall. This becomes important when trying to balance the demands of speech and music.

The wide/short orientation, on the other hand, results in side walls that are too far apart to provide any benefit. Sound reflections from those distant side walls will be late, creating disturbing echoes.

The long/narrow orientation opens up the possibility of creating a relatively "live" front end, with more sound-absorbing material as we move away from the platform. This can provide support and enhancement to choral singing to compensate for the limited reverberation required for speech. I have used this "live end dead end" approach successfully in several projects.

The long/narrow approach works much better with overhead sound-reflecting panels (clouds). These can provide clarity and support to unamplified sound by redirecting multiple sound reflectors from the platform to listeners.

Lastly, every single great concert hall in the world is longer than narrow — often much longer than narrow. The only (successful) exceptions to this rule involve sophisticated designs to make a space that doesn't *look* long and narrow *act* long and narrow.

Every single successful multi-purpose hall in the world is long and narrow, including the Kravis Center in Palm Beach, Pikes Peak Center, the New Jersey Performing Arts Center; you name it. There may be *smaller* successful multipurpose halls that are wider and short, but smaller halls can work in spite of breaking some rules because of size. My successful multi-purpose auditorium projects are all long and narrow.

Most protestant church sanctuaries have been long and narrow, until recently. I understand that the current fashion is to construct churches that are short and wide. However, in assembly space design (as in many other things) the best guide is long-term historical experience, rather than the passing fad of the moment.

Noise Control

Noise control is the single most important aspect of the acoustics of a church sanctuary, yet few people even consider this to be an acoustical issue. An air-handling unit on the roof of the sanctuary or a mechanical room adjacent to the sanctuary produces a haze of noise and vibration that masks speech and dulls music. This background noise precludes acoustical quality. Although heroic methods are available for nearby noisemakers, placing the mechanical equipment so that it is sufficiently distant and structurally isolated from the sanctuary makes the essential task of noise control much more tractable.

A church constructed in the same manner as a shopping mall will

never have the rich acoustics necessary for sacred music. Gypsumboard walls absorb low frequencies, making for weak organ sound. Flimsy construction also allows noise from the outside to enter the church, combining with the noise from the lights and the mechanical system. This creates a fog of noise through which nothing can be heard with clarity.

There are many other aspects to excellent acoustics for church sanctuaries, including the issue of sound diffusion, or that perennial favorite: Should we put carpet on the floor? However, if proper room shaping, distant location of noisy machines, and sufficiently sturdy construction are all part of the early design, there is a very good chance of coming up with a design that is acoustically superior to that of the vast majority of churches.

The appropriate acoustical approach depends on the congregation. Whereas both music and speech are important for all churches, some congregations feel that speech is so important that unambiguous speech clarity is worth sacrificing the sound of the organ, choir, and congregation. Furthermore, churches that rely heavily on electronic amplification do so because the congregation prefers that kind of sound. For these, the "dead" room approach is clearly the way to go.

Congregations often blame problems with clarity in their space on reverberation. They are often too willing to sacrifice some of the "liveness"—with all of its acoustical benefits—for some speech clarity. Broadening our perspective to consider sound-system design, room geometry, background noise, even the art of elocution, can enable us to savor the riches of a reverberant sacred environment, while still being able to apprehend the spoken word.

With a little forethought and a little care, we could have a landscape dotted with acoustically superb church sanctuaries. Surely, clients want their churches to have excellent acoustics. Yet precious few churches do. This is an opportunity for architects to really distinguish themselves from the pack.

Sound Systems

Why I Hate Sound Systems

I don't really hate sound systems. I hate when sound systems are used when they are not necessary. It puts me off to sit anticipating a performance in a recital or concert hall — where one expects to hear the merest pianissimo

passage—and hear someone make an announcement through an overly loud sound system.

There is agreement amongst classical music lovers—and lovers of good drama—that amplification is bad. No one wants to hear a chamber music or symphony concert or a Shakespeare play amplified (unless you are at a large outdoor venue). But why not? After all, the quality of electronics is very high these days, and getting better.

First, sound systems are almost always operated at an unnaturally loud level. This has two negative effects: it makes for an artificial sound, and it discourages attentive listening. With loud amplification, there is no reason for people to be still, concentrate and really listen. But active listening is what the audience contributes to a performance. By making listening easy and passive, we lose something precious.

On very rare occasions, one hears a sound system that is not too loud and sounds quite natural. However, I *still* don't want to hear amplified concerts. Why? To understand why we have to look at how sound systems function.

The performer creates sound (pressure disturbances in air). This sound is converted into a small electrical signal by a microphone. The electrical signal is conveyed by wire to a series of amplifiers, which boost this signal. The amplified electrical signal travels through wire to a loudspeaker (or several loudspeakers). The loudspeaker must be located elsewhere from the performer, otherwise there would be horrid feedback. This is the crux of the matter.

The listener hears all sound from the loudspeaker, from a location other than the performer. A complex sound field is thus completely flattened. Let me explain. When a string quartet performs, each player sits in a slightly different location. Here is the first violin; here is the second violin; here is the viola; here is the 'cello. Each instrument has different directional characteristics, which vary with pitch and the manner in which each note is played. The intensity of each instrument varies with direction. Furthermore, the players move about while they are performing. All of these factors result in the separate instruments each having a slightly different acoustical relationship with the room in which they are playing. The result is a rich kaleidoscope of spatial information.

Similarly, when listening to the spoken word, our directional hearing allows us to focus on the speaker. This is a tremendous help sorting out the characters in a drama, but even if there is a single person talking, localization helps us focus our attention. Our ears are very good at picking up spatial information in sound. This is what enables us to hear and understand a conversation in a crowded room. It is part of what makes our world

seem real and three-dimensional. After all, we can only see towards the front, but our audible world surrounds us. When we close our eyes, we still exist in a three-dimensional, real soundscape.

The spatial information created by performers enriches the experience of listening and makes it seem real and natural. It also enhances the music itself by allowing the listener to follow separate lines more clearly (in the same way that it helps us make out conversation in a crowded room). Thus the listener is able to hear more of the music itself in a live performance.

It is this complex spatial information that allows some clarity for musical line in a reverberant room. The reverberant room helps enhance the music by surrounding us in sound, yet we can still make out individual voices. Amplified music is far less tolerant of reverberation than is live music. One can be enveloped by amplified music only by being buried in decibels— obliterating such niceties as individual voices.

This spatial aspect is the essential difference between a live performance and an amplified performance. This is why it is still worthwhile to travel for hours to hear a live performance, rather than to stay home and listen to a recording, and why amplified popular music is often better heard at home.

I am not a Luddite. I do not oppose technology. I drive a car. I am writing this on a computer, not with a quill pen. There are many situations where sound systems provide a tremendous benefit. There are spaces which are simply too large for speech to be heard at the distance between the speaker and the audience. Or, a sound system may make it possible to understand speech in a space that was intended for organ. Or, the audience may be in another place entirely from the performer. But just as it is beneficial to walk when one can, it is nearly always preferable to design a space so that speech can be understood without amplification if possible.

Why I Love Sound Systems

Sound systems provide an acoustical result that is in some ways counter to the room. They may allow you to hear a performer who is not physically in the room. Or they may allow you to hear a performer or speaker who does not generate a strong enough sound due to distance, or poor room design (background noise), or sheer audience inattention. The most common use is to make it possible to understand speech in situations where it would otherwise be impossible. They are particularly useful in highly reverberant spaces like churches. Perhaps you have been in an old, high stone church where the sound bounces around forever. Organists and

choir directors love these churches. They are wonderful to sing in. However, it is almost impossible to understand speech at a distance in such a space — without a properly designed sound system. So the sound system allows us to have two mutually exclusive acoustical conditions simultaneously.

A poorly designed system — there are more of these than properly designed ones—can make it even more difficult to understand speech. This is because a poorly designed sound system merely makes sound louder. The sound is louder and so is the reverberation that covers it up. There is really no need for a higher sound level in a highly reverberant space; the reverberation itself amplifies sound quite enough. Furthermore, many poorly designed systems have too many loudspeakers. Additional loudspeakers create a sort of artificial reverberation that interferes with clarity. The only loudspeaker that contributes to clearly understanding speech is the one near the listener; all the others just contribute to the din.

When loudspeakers are mounted close to each other, sound waves from each speaker interfere with one another. This can send sound off in all sorts of unanticipated directions. Figure 17 shows what happens when you place three loudspeakers next to each other, three feet apart. Interference in the frequency range with wavelengths of three feet ([1130 ft/sec.]/[3 ft.] = 377 Hz.) produces large lobes of sound going off to the

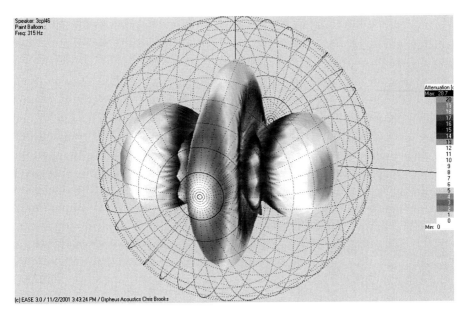

Figure 17

sides. This produced extremely annoying echoes off the distant side walls of the sanctuary where the group of loudspeakers that produced this image were hung.

The key to speech clarity in a reverberant space is to boost the voice over the reverberation, without simultaneously increasing the reverberation. You aim the sound at where people are, and avoid sending it elsewhere. To illustrate how this is done, imagine that you are with a friend in a highly reverberant cathedral. If you stand close enough to your friend, you can easily converse. If you want to increase the distance at which you can understand each other, you can cup your hands to create a megaphone. This will increase the directivity of your voice, increasing the distance at which you can be clearly understood. Note that if you simply shout it just makes things worse.

Similarly, there are two ways that a sound system can be designed to provide speech intelligibility in a reverberant space: 1) bring loudspeakers close to the listeners; 2) "beam" sound at the listeners with directional loudspeakers. Bringing loudspeakers close to the listeners requires more loudspeakers; otherwise, bringing a loudspeaker closer to one listener takes it farther from another. This is called a distributed system. Directional loudspeakers need to be large, and have a clear shot at the congregation. Highly directional loudspeakers can be enormous, and they are not exactly inspiring to look at.

A distributed system is easier on the eyes. A distributed system requires a signal delay system to give the impression that the talker is located in the front, rather than in the nearest loudspeaker. One can take the distributed system approach to the extreme by installing the loudspeakers in the pews. This is an excellent approach for very large, highly reverberant churches where nothing else would work. However, installation is very labor intensive.

A large central cluster can be less expensive, but a large loudspeaker cluster flying directly over the chancel can be a real eyesore. Furthermore, some people do not like the sound quality of highly directional loudspeakers.

Another approach uses digital signal processing to aim sound very precisely at the congregation. The digital line array is a linear cluster of loudspeakers with strong directionality created by subtly adjusting the timing of the individual loudspeakers. This device has provided excellent speech intelligibility in highly reverberant spaces such as Philadelphia's 30th Street Station (with a 9-second reverberation time). These devices are the way to go in highly reverberant church sanctuaries where it is simply not possible to alter the acoustics of the space.

The sound system is rarely considered until late in the architectural design. However, early consideration can open up approaches that might not be possible later. For instance, a large central cluster can be integrated into the visual aesthetics of the room. This may open up the possibility of a cost-effective approach to providing speech clarity in a reverberant sanctuary.

Note that I haven't said a word about amplified music. Honestly, I'm not a great fan of amplified music, so perhaps I'm not the best person to write about this subject. Amplified music usually requires more power and loudspeakers to cover a wider frequency range. A good music system requires subwoofers to cover the very low frequencies, and often requires monitors for the musicians. Each additional loudspeaker contributes to muddying up sound in the space.

The difficulty arises from the common confusion in our using the word "hear" to mean "hear clearly" or "understand." This is compounded by the fact that sound levels from electronic instruments can be increased almost indefinitely, without any effort on the part of the musician. The sound level of an "acoustic" instrument is partly the result of effort on the part of a performer. There is a limit to how loud you can play such an instrument, and it takes work. Electronic instruments have no such limitation; just turn the knob clockwise. As a result amplified groups tend to get louder and louder, each player turning up to hear his own sound, like people shouting for conversation at a crowded party. Furthermore, with "acoustic" instruments, the individual player adjusts his volume, reacting moment by moment to the shifting requirements of the music. Electronic instrument levels are set from a board. The solution, as usual, is to turn down the volume.

At every moment in music there is a voice to be brought out. The other voices must support the solo voice by playing distinctly softer. Sometimes it is obvious which voice should come out. Sometimes it requires judgment. In a Bach fugue, for instance, the solo may change from voice to voice every few notes. Regardless—at every moment, everyone in the ensemble should be aware of and agree on just who has the solo, and who is accompanying, and play accordingly.

Clarity is achieved by deciding which voice is to be brought out, and suppressing the volume of the other voices relative to the solo— NOT by making the solo yet louder. The contrast in loudness is what brings out the important voice, and allows that voice to have its emotional impact. If everyone is loud, no voice can come to the top. With everyone playing at the same loud volume, nothing clear or penetrating can be communicated with the music.

I recommend that amplified bands rehearse with minimum amplification: amplifying only those instruments—such as electric guitars—that required amplification to be audible. All other instruments and voices should rehearse unamplified to learn how to balance themselves— in other words, how to play as a sensitive member of an ensemble. In particular this applies to drummers. A drummer who is a musician can play as softly as the music requires. And music rarely requires that the drummer be the loudest instrument.

Many people advocate the use of in-ear monitors for musicians. These protect the musician's ears from sound in the space, like an earplug. They provide a clear mix of the music directly to the his ears with maximum clarity. Furthermore, they come with level limiters to avoid inadvertently deafening the musician. Since the monitors are in the musicians' ears, they do not degrade clarity within the room.

A good sound system comes as close as one gets in life to having your cake and eating it too: clarity within a reverberant space is the holy grail of acoustics.

Classroom Acoustics

A while ago, I participated in a discussion with the Technical Committee on Architectural Acoustics of the Acoustical Society of America on the acoustics of classrooms. The publication that resulted from that meeting (and others) contains much useful information on acoustical design for classrooms.[5] This chapter contains material from that report.

Classrooms (and meeting rooms) generally have poor acoustics—the room in which the technical committee met was a prime example. The noisy HVAC system, complete lack of sound isolation, and no thought given to room acoustics combined to make listening an unpleasant chore. Unfortunately, this is simply the way rooms are built nowadays. As a result, in order to be heard in a small room (seating roughly 100 people), the speakers spent much of their time fussing with a lavaliere microphone, which periodically produced squeals of ear-biting feedback. Keep in mind that these were sound professionals.

According to a study discussed at the meeting, young children require yet better acoustical conditions than do adults to understand speech. This observation should ring true to anyone with children.

Classrooms and meeting rooms are currently designed in the following manner. First, very high background noise levels are guaranteed by mounting noisy HVAC equipment directly over the room, or even within

the room itself, with almost nothing done to attenuate sound and vibration. Second, the ceiling is covered with acoustical tile so that no sound reflections reinforce the sound of the speaker's voice. Third, no provision is made for keeping outside noise from entering the room. The result is predictable: perfectly dreadful acoustics. And so we apply the electronic band-aid.

This creates a vicious cycle. High background noise levels necessitate the acoustical ceiling to dampen reverberant noise. Too much reverberation, no reinforcing sound reflections, plus the background noise necessitate a sound system. The sound system increases the overall noise level. Listeners no longer have to be quiet or pay attention to hear the speaker, so they fidget and talk; background noise increases; the sound system volume is turned up. And everyone goes deaf, or mad, or both.

Considering all that goes into running an elementary school class, how is a teacher also going to deal with a sound system, when professionals regularly make a hash of it? During class discussions is the teacher going to pass the microphone around like on daytime TV? How is anyone ever going to learn to sit still and listen?

As a child, I attended elementary school in an antediluvian building with real plaster walls and ceilings and no forced air. Steam conveyed heat to the classroom, and we opened the windows onto a quiet, residential area of Brooklyn for ventilation. We understood the teacher, as well as can be expected from school children in a relatively quiet, modest-sized room built of honest materials. The current crisis in classroom acoustics is, in large part, a result of tremendous progress in building technology, with all its attendant dismal acoustical results. As Giuseppe Verdi is reputed to have said, "Let us return to the past, that would be progress."

To understand what we ought to do in classrooms requires thinking about speech intelligibility, because the primary function of classrooms is to teach and learn, and most teaching and learning happens through the medium of speech. Speech intelligibility is a function of the level of signal (the speech) above noise. There are three main sources of noise: mechanical systems, noise from other classrooms, and sound in the room. Sound in the room can be sustained by bouncing around the hard surfaces of a room. Here are a few requirements for good acoustics in classrooms.

Low Reverberation

Reverberation interferes with speech by smearing the sound of speech through time. It also sustains and enhances any other noise that may be in the room. The Acoustical Society report recommends that reverberation be in the range of 0.5 to 0.6 seconds (depending on the size of the room).

REMOTE LOCATION OF VENTILATION MACHINERY

One of the most unfortunate trends in the design of new classrooms is the location of heating/ventilation units in the classrooms. The steady noise from these devices not only obscures speech, but it can lull students to sleep. The reason these are placed in classrooms is to save money. As the Acoustical Society brochure points out, however, the additional sick days for teachers who have to shout to be heard ought to more than make up for the additional cost of a quieter system.

A quieter system requires remote location of ventilation machinery in a distribution designed to radically reduce noise.

SUBSTANTIAL CONSTRUCTION

Lightweight gypsumboard walls do not provide enough of a barrier to sound between classrooms. The sound of voices from another classroom can be very distracting to students who are trying to understand what their teacher is saying. This was less of a problem in older school buildings, which were constructed with solid masonry and plaster walls. Here is another example of progress in ease of construction and reduction in costs having an adverse affect on acoustics.

HARMFUL SOUND REFLECTIONS VS. USEFUL SOUND REFLECTIONS

Reverberation can interfere with speech, especially in a room with restive children and other sources of noise. The ASA recommends that mid-frequency reverberation times in classrooms be between 0.5 and 0.6 seconds. On the other hand, sound reflections can help support the speaking voice and give the speaker a useful sense of feedback from the room.

The Uses and Abuses of Acoustical Tile

Before the good folks who sell these materials put out a contract on my life, let me state unequivocally that there *are* good uses for acoustical tile and other off-the-shelf panel sound absorbers—many good uses. However, the ceiling of a church sanctuary is not one of them. Nor is an acoustical-tile ceiling appropriate in an auditorium.

Because of the unfortunate name "acoustical tile," there is a tendency to think of these products as being miraculous: no matter the application, they will improve the acoustics. This is false. The term "acoustical" for materials that absorb sound is misleading because *all* materials have acoustical properties. All materials both absorb and reflect sound to varying degrees.

What does acoustical tile do? It absorbs sound particularly well. This is accomplished mainly by pores in the tile into which sound waves force air. The friction of the air rubbing against the walls of these pores turns some of the sound energy into heat. The rest of this sound energy either bounces off the tile or passes through. The sound that passes through the ceiling tile is absorbed in the ceiling plenum above.

If one wants to absorb sound, the ceiling is a very convenient place for sound-absorbing material. Contemporary rooms tend to have large floor plans and low ceilings. The ceiling in such a room has a very large surface area compared to its walls. In addition, sound-absorbing materials are by their nature fragile. Locating them on the ceiling protects them from damage.

Ceiling tiles vary a great deal in how well they absorb sound. For critical applications, such as open-plan offices, it can be worth the extra expense to get a highly effective model of ceiling tile (some designed specifically for such offices). Their efficacy is also influenced by the air space behind the tile. In an application where it is important to absorb sound across the entire spectrum, such as in a broadcast or recording studio, acoustical tile can be a very useful tool, though other measures may be needed for sound diffusion and additional absorption in the lower frequencies.

Do we always, in every single case, want to absorb sound? Sometimes one improves acoustics by absorbing sound. And sometimes one improves acoustics by assiduously avoiding the absorption of sound. It depends on the function of the space.

In busy offices, in factories, cafeterias, and other noisy spaces, sound absorption is one way to help control the din. Broadcast and recording studios also benefit from sound absorption. Acoustical tile is an important tool for these sorts of spaces.

The opposite holds in spaces where people come to hear and create sound, such as churches, recital halls, lecture halls, conference rooms. In these spaces, people work hard to create sound with the intention that it can be heard. In such spaces, acoustical tile has no place. In houses of worship and performance spaces, *people* should provide the largest area of sound-absorbing material.

Even in special cases, where one does want to absorb sound in such "performance spaces," the placement of sound-absorbing material has to be considered very carefully. It is usually best if that sound absorbing material is movable so that it can be taken *out* of the space when not needed.

Acoustical ceiling tiles (and other special sound-absorbing products) do have their uses. These are not, however, miracle materials. They serve

a particular function. Sometimes that function is appropriate. And some-
times it is most emphatically not.

What Is the Difference Between a Concert Hall and an Open-Plan Office?

A concert hall requires wonderful acoustics.
An open-plan office requires good acoustics. (What's the difference?)

In a concert hall, carpet should be absolutely minimized.
In an office, carpet is absolutely essential.

In a concert hall, we want to be surrounded by rich, reverberant sound.
In an office, we don't want to be aware of sound at all.

In a concert hall, we want long, long reverberation times.
In an office, open sky is the acoustical ideal (minimal reverberation).

In a concert hall, we want to be able to hear very soft sounds from far away
with clarity.
In an office, we don't want to be able to understand a telephone conversation at
the next desk.

An air handler on the roof is a problem for an office.
An air handler on the roof is a *disaster* for a concert hall.

Figure 18. What do you do if your company wants to hold a concert series in the
office? Drawing by Bot Roda.

In a concert hall, we want the complete exclusion of background noise; no sound should be audible that is not created by the performer.
In an office, we *need* background noise to protect privacy and to shield us from distraction.

In a concert hall, we want a direct line of sight to the performer.
In an office, we want to be hidden behind a barrier. Any performers are to be ignored.

Electronic sound masking can be beneficial in an office.
Some concert halls have sound masking, but this is neither intentional nor desirable.

In a concert hall, audience members are packed together as tightly as modern sensibilities (and girths) will allow.
In an office, we want elbowroom (though we don't always get it).

A concert hall is designed so that we can enjoy sound.
An office is designed so that we can ignore sound.

What if (to save money) a symphony orchestra decided to build a multipurpose concert hall/administrative office? Could this work?
What do you do if your company wants to hold a concert series in the office?

4. Rooms for Listening

I call architecture frozen music.
— Johann Wolfgang von Goethe (1749–1832)

This chapter is a collection of sections about some specific rooms for listening. It is not meant to be thorough or to cover every single type of listening space; it is based on my admittedly limited personal experience. Some of the projects described are ones with which I was involved; others are examples that illustrate the issues of scale, quality, or overlooked opportunities. These chapters reflect, partially, the culture shock that I experienced when I moved from working on world-class projects at a world-class New York acoustical consulting firm to my own practice based in Lancaster, Pennsylvania. When I started my practice, it seemed to me that many of the principles that applied to world-class projects could also be applied to more modest ones. The smaller scale of these projects opened up an opportunity for acoustical quality, since acoustical success is so much more difficult with a very large space. However, the impediment of large size was replaced by another one: the limitations of very tight budgets. This impediment can be overcome by the application of imagination and early planning — especially early planning.

A National Treasure in Our Backyard

How many people are aware that one of the greatest concert halls in the world is located on top of a savings bank in downtown Troy, New York? The bank, by the way, is still in business. For me, attending a concert in Troy was well worth the seven-hour drive.

The Troy Savings Bank Music Hall[1] was designed by George Brown

94

Post and opened in 1875.[2] It holds 1,250 people in seats that are small for modern posteriors. It is a surprisingly simple space: a modest-sized rectangular box (72 feet wide, 125 feet long, and 60 feet high) with two rows of boxes on the sides and two balconies. The balconies step back, so that there are few seats hidden under a balcony.

There is a moderate amount of architectural ornamentation, including a narrow, curved sound-reflecting canopy over the rear of the performance platform just under the organ pipes. It is a tenet of architectural acoustics, which I believe, that ornamentation is good, the more the better. Yet, Troy is wonderful, even with relatively little ornamentation. I offer no explanation for this curious fact.

The performance platform is narrow and in the same room as the audience; there is no separate stagehouse. The ceiling is flat, curving where it meets the walls. For ventilation, air exits through a hole in the ceiling; there is no mechanical ventilation. Although the hall is not well isolated from outside noise, there is precious little noise in Troy, New York, on a Sunday afternoon.

How does it sound? In a word, wonderful: strong, rich and clear. I once heard the New York Philomusica play a program of Mozart and Haydn here.[3] This tiny chamber orchestra produced a full, rich sound that filled the Troy hall during forte passages. Accents produced a visceral effect, and the softest note had life and energy. A single bass viol filled the hall with a warm rich sound that blended completely with the sound of the ensemble. One can hear these marvelous acoustics by listening to CDs on the Dorian label, many of which are recorded in this hall.

Why is it so difficult to build a hall that compares acoustically to the Troy Savings Bank Music Hall? This is a simple room, using common masonry construction. Far more complicated, difficult designs are built with a fraction of the acoustical effect. One fundamental problem is economics. It is difficult to pay for the massive construction in a hall of the scale of the Troy hall. If built today, the Troy Savings Bank Music Hall would seat less than a thousand people. It is difficult to cover the fees for first-rate performers in a modest-sized room such as this one. This is probably why some of the best acoustics in America is to be found on college campuses where the halls can be subsidized by the school, relieving the financial dependence on ticket sales.

For a period in the middle of the last century, architects turned up their noses at the simple rectangular box. I still run into this with architects with no experience in performance spaces. Their first drafts may be fan-shaped or even a tear-drop in plan. Among more experienced architects, there has been a return to the shoebox form (or variations on that

theme), especially for concert and recital halls. As Troy demonstrates, it is difficult to improve on the simple shoe-box.

Because modern audiences won't put up with the slightest variation in temperature, we must have ventilation systems in halls. Clients find it difficult to believe that the nearly inaudible whoosh from the ventilation system destroys acoustics. But it does. Troy is served by a silent, passive ventilation system: no machines. This approach is certainly easier to pull off in a northern climate with a tall space. It is quite possible to keep audiences cool and ventilated without making noise, but this requires considering the mechanical system a fundamental aspect of acoustical design.

The Troy Savings Bank Music Hall was built well before such technological marvels as artificial reverberation, computer modeling, and complex measurement techniques. It is a simple rectangular box with no gadgets, no tricks—just simply wonderful acoustics. It demonstrates that modest size and getting a few things right can go a long way.

The Clemens Theatre

I knew the theatre, located in Christopher Dock Mennanite High School, Lansdale, PA, was a success when the school principal, Elaine Moyer, gave her introductory speech from the stage. As she began speaking, the audience members began to quiet down. Their pleasant murmur reached a normal level of quiet, but that wasn't enough for her to be heard—she was speaking too softly. Then something magical happened that can only happen in halls with low enough background noise. The audience members continued to get softer and softer, until they were truly still. And from the back of the hall, I could hear her speaking, her voice no louder than before, but perfectly clear.

After Mrs. Moyer's short speech, the entire audience sang Christmas carols. Without sheet music, they sang in four-part harmony, in the Mennonite fashion. The Clemens Theatre doesn't quite have the reverberation of a cathedral, but every voice is supported and each blends effortlessly with the others. It is a pleasure to sing and to listen within its walls.

The main fare for the evening was Gian Carlo Mennotti's well-crafted and affecting chamber opera, *Amahl and the Night Visitors*. The small scale of the work is well suited to the scale of this theatre. There was no need to amplify any of the singers, not even Amahl, sung by the then ten-year-old Isaac Franks. Overall the singing was very good, but Kendra Good Rittenhouse as Amahl's mother deserves special mention; I was nearly in tears during two of her arias.

A particularly beautiful part of the performance was the student choir as shepherds. They entered from the rear of the house, and so the ear was treated to the sound of their singing as they wound their way from the back of the theatre down to the stage.

I had heard this same work the week before in Baltimore's well-known Meyerhoff Symphony Hall. The Meyerhoff is a vastly larger hall (2,467 seats, compared to 202), so perhaps comparisons are unfair. The acoustics of the Meyerhoff are known to be quite good, and I have enjoyed hearing the Baltimore Symphony perform there. However, for that performance of *Amahl*, the voices were all amplified. The resulting mishmash was neither flattering to the vocalists nor an aid to understanding the words.

Such electronic filtering is not necessary in the Clemens Theatre. Thanks to its small size, low background noise, and supportive acoustics, the human voice can be heard there in all its purity.

The original idea for the theatre was that it was to be merely a lecture hall. But during the early stages of design, the client saw that the hall could address many more functions. For example, the music department needed a space to rehearse the chorus. Currently the theatre is used for a broad variety of functions, including plays, chamber music recitals, rehearsal, and chapel. The opening night's performance demonstrated admirably every acoustical function.

The simple design provides the ability to support all of these functions. The Clemens Theatre is basically rectangular in shape, narrowing towards the back. It seats 202 on a slope that gets steeper in three sections towards the back. As a result, sightlines are excellent all through the theatre. Sitting in the back row, I saw and heard perfectly. The stage is in the same room as the audience — as is the case in all great concert halls — rather than separated behind a proscenium arch. Walls are of rose-colored split-faced block. For extra mass, they are filled with grout. The trusses and ductwork are exposed and blacked out, making for maximum height in the hall. Entrance to the hall is through double doors or doors separated by corridors to, block outside noise.

Considerable pains were taken to keep the ventilation system inaudible. Measures taken to quiet the system include fiberglass-lined ducts, plenums for both supply and return, active noise control, and avoidance of any terminal devices in the hall. When I stuck my ear in the return air grill, I heard nothing but only felt a slight breeze flow past my head. The silent background allows for much greater clarity in the sound than in most halls.

I have been in theatres where much of the budget has been spent on superficial effect, to the detriment of acoustics: gaudy ornamentation and

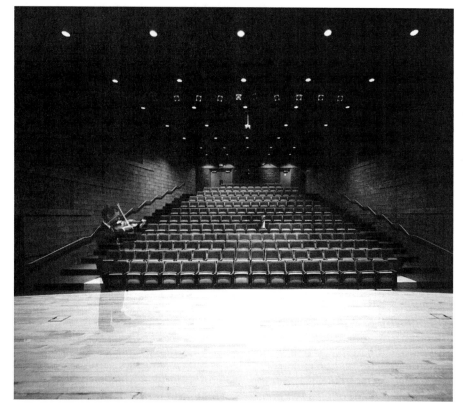

Figure 19. The Clemens Theatre. Photo by John Herr.

architectural fancy on the one hand, gypsumboard walls and noisy ventilation on the other. Perhaps it's just my professional perspective, but during a performance, when the lights are down, I don't notice all that gold leaf. If the acoustics are mediocre, on the other hand, I would prefer to stay at home with my stereo system.

The Clemens Theatre was built by High Industries, and the craftsmanship is excellent, though not fancy (in keeping with Mennonite philosophy). Due to a tight budget (the usual case for schools) Steve Wise and Keith Falco of Greenfield Architects had to make difficult choices during the design. But the architects let the function of the hall — acoustics in particular — drive these choices. The result is a simple, elegant space, with strong and clear acoustics.

I don't mean to exaggerate the achievement of excellent acoustics for a 200-seat space. It simply took doing a few things right. What is surprising is how rarely it happens. I see an opportunity here.

Congress Hall in Philadelphia

In the hopes of learning more about the art of business, I recently read Peter M. Senge's book *The Fifth Discipline*. To my surprise, on page xiv of the introduction, I stumbled upon the word "acoustics." Mr. Senge contends that people learn together through dialogue (from the Greek "flow of ideas"), and he singles out Congress Hall in Philadelphia, where the United States Congress met in the 1790s, as a superb room for dialogue. "The Congress Hall is a room designed for conversation. The acoustics are exceptional. One hundred and fifty people can carry on a conversation as if they were seated in a living room."[4] I have been in this remarkable room and I concur.

Congress Hall is located on the corner of Chestnut and 6th streets in downtown Philadelphia. Constructed between the years 1787 and 1789 as the Philadelphia County Court House, it was offered rent-free to the federal government as an enticement to keep the nation's capital in Philadelphia; and it served as the meeting place of the U.S. Congress from 1790 to 1800. The House of Representatives met on the main floor, while the Senate assembled upstairs. Among the historic events that took place here were the presidential inaugurations of George Washington (his second) and John Adams.[5]

Let us look at some of the elements that make this main floor room so well suited for the ebb and flow of ideas:

- It seats 150 people. A larger room would lack intimacy, yet fewer people would bring fewer ideas.
- Room surfaces support the speaking voice.
- There is a high platform in front, for someone to maintain order and address the assembly.
- It is set back from the street and buffered from outside noise.
- The semicircular seating plan optimizes interaction among the participants.
- Windows set high in the walls allow lots of natural light but no distracting outside views.
- There is no noise from mechanical air-conditioning. On the negative side, we know from history — and from contemporary experience of summer in Philadelphia — that it was hot and stuffy in that room.

In contrast, the typical contemporary hotel ballroom/convention room seems not to have been designed at all.

- The ventilation system is loud.
- Distracting noises break in from adjoining rooms.
- Seating is flat, with no raised platform in the front.
- Natural light is rare.
- Few of these rooms provide any support for the voice at all, since nearly all room surfaces absorb sound. This approach is necessary, since the high noise levels would be unbearable in a more reverberant room.

As a result of these conditions, discussion often takes place through the medium of a portable sound system. Much valuable time is spent fussing with this impediment to communication. The result is either far too loud or inaudible. And what does one do when there is discussion amongst members of the group? Passing a microphone around really puts a crimp on the spontaneous exchange of ideas.

Thus, in nearly two and a quarter centuries of technological progress, our conditions for group dialogue are worse than those in Congress Hall in 1790 — except that now we sweat less.

The technology to create rooms that are quiet and support speech with appropriate room acoustics is well understood. It is currently possible to build inaudible HVAC systems, though this is rarely done in modern conference rooms. There has been an explosion in the number of rooms for conferences in hotels around the country, yet few demonstrate any consideration for acoustics past acoustical ceiling tile. Again, I see an opportunity for improvement here.

A Diamond in the Rough

When the historic Fulton Opera House in downtown Lancaster, Pennsylvania, was being renovated, the resident Actors' Company of Pennsylvania rented a temporary home for the 1994 season in the Lancaster Trust Building. Just a block from the Fulton, the Trust Building is a beautifully renovated nineteenth-century bank building. Its size, location and wonderful ambiance made it a good space for the performing arts. However, the acoustics were impossible — impossibly reverberant. Sound seemed never to die in that room.

George Skiadas, local real-estate developer and the owner of the Trust Building, had used the room for everything from weddings to raves. He occasionally presented chamber music concerts there. Many people had concluded that the room was not suitable for theatre because of the reverberant acoustics.

In January of 1994, I was called in by Actors' Company to see if anything could be done to fix the "dreadful acoustics." Upon entering the room, my first impression was "wow, what wonderful acoustics!" The sound, due to the height of the room and its massive stone walls, seemed to last forever. Not a word could be understood in that heavenly din, but what a sound! Realizing that we had a diamond in the rough, I agreed to look into the possibility of creating an acoustical design that would work for drama.

The first problem to be attacked was noise—the mortal enemy of excellent acoustics. Great acoustics with background noise is like looking at a fine oil painting through dusty glass. We were able to completely silence the ventilation system (by simply turning it off).[6] The massive stone walls took care of traffic noise. Lighting noise was successfully banished by mounting the dimmers in the basement. Admittedly, turning off the HVAC system is not a universally applicable way to eliminate noise, but it does work in a pinch. This approach is standard practice for recording studios, and it can be used to demonstrate the surprising acoustical improvement from noise elimination. Best, of course, is to build a silent system.

Based on an approach that has been used successfully in much larger halls, I developed a set of large, sound reflecting canopies to divide the room into upper and lower volumes. I then analyzed the acoustics of the room mathematically in terms of the relationship between these two volumes: reverberation in the lower volume (where the audience sits) is affected by reverberation in the upper chamber.[7] A scale model had been built for the most recent renovation of the Trust Building, and I used this model to develop the geometry of the sound canopies using light reflections. The goal was excellent speech intelligibility, while retaining some of the room's warmth and reverberation. No amplification of sound was to be used.

John Whiting, scenic and lighting designer at Franklin & Marshall College in Lancaster, worked closely with me to make these ideas practical. The sound panels—plywood with fiberglass on the upper side—were built by Actors' Company in their shop. The entire theatre—panels, lighting, set, raked seating—was assembled by the hard-working Actors' Company crew in a single week.

We heard the acoustical result at the dress rehearsal. It was just as intended. Speech was clear and distinct, with no blurring and no interference from noise, yet warm and full. Because of the double volume design, when an actor spoke, his voice was direct and clear, while powerful singing excited the full room and it bloomed with wonderful reverberation. Most importantly, the clients were happy with the sound.

In 1995, the Actors Company moved back into its old home in the

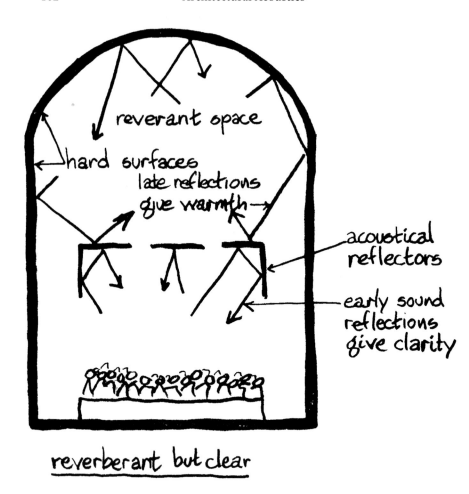

reverberant but clear

Figure 20

newly renovated Fulton Opera House. The Actors' Company Theatre in the Lancaster Trust Building was dismantled. The building still stands. It was used for a short period of time as a rehearsal space for the rock band Live. Currently, the building silently awaits its destiny.

The brief flourishing of the Actor's Company Theatre demonstrates that it is possible with some imagination to build a successful theatre in small space on a shoestring budget. It also demonstrates the possibilities afforded by existing older buildings. Another example of an intimate theatre, in an even larger older reverberant space, is the Royal Exchange Theatre in Manchester, England,[8] a 700-seat theatre-in-the round in the enormous, old Manchester Royal Exchange Building. Because the audience

is stacked on three levels with the stage in the middle, the distance from the farthest seat to the stage is only 42 feet. The central hall of the Royal Exchange building in which the theatre is set (like a lunar landing module) is large enough to produce a reverberation time of 7.5 seconds. This external reverberant volume is utilized for sound effects like thunder or the approach of distant cavalry. Opportunities to achieve results like these abound in the buildings of our aging inner cities. Let's seek them out!

The Binns Rehearsal Room

Here is the story of a room changing its function. The Binns Rehearsal Room was originally intended as a rehearsal room, but became a recital hall because of its acoustics.

Rehearsal room acoustics are usually not intended to support and flatter the performer but rather for optimum clarity. Rehearsal rooms are workshops, not performance spaces. Furthermore, rehearsal rooms are usually small relative to the size of the ensemble that plays in them. They lack audience members who absorb sound. For all of these reasons, rehearsal rooms are usually built with healthy amounts of sound-absorbent material, resulting in a "dry" acoustic.

The Pennsylvania Academy of Music is a dynamic and growing community music school in Lancaster, Pennsylvania. The school decided to create a new rehearsal room by expanding its building out over the rear parking lot. When I met with the architect, David Drasba, and the directors of the school, Francis Veri and Michael Jamanis, we decided that this rehearsal room was going to be different from the usual, because it wasn't going to be just a rehearsal room. It would serve as a recording studio, a room for master classes, and an intimate performance space.

With this flexible use in mind, David Drasba (the architect) and I designed a room that could take on a variety of acoustical personalities. Ordinarily, the room is astonishingly reverberant for such a small space. When tamer acoustics are required, sound-absorbing panels can be brought into the room and hung on the walls. When removed, the original, reverberant condition is restored.

This reverberation results, in part, from the height of the ceiling. Because of the room's location, there was a strict constraint on the height of the roof. We pushed that ceiling up as high as possible, squeezing ducts for ventilation between the ceiling and roof. The resulting coffered ceiling helps break up sound in the room, an important contribution to the acoustics.

In nearly all performance spaces, the ventilation system creates a haze of sound through which one can dimly make out the performance. In this room, much attention was given to keeping the ventilation system as quiet as possible. This was done by locating the air-handlers at a distance from the room and by very slow air speeds. As a result, air unobtrusively slinks in and out, without masking the sound of the musicians.

How does the room sound? It gives strong support to speech. No sound system is needed here, as the room itself amplifies the speaking voice. For music, the room allows performers the rare opportunity to plumb the quiet depths of the dynamic range. When half filled with audience, the sound is lively, strong, and clear.

To reduce reverberation for rehearsals and recordings, sound-absorbing panels on coasters are brought into the room to make up for some of the sound absorption provided by the audience during concerts.

Even with this extra sound absorption, however, more powerful performers, such as opera singers or brass, can overpower the room and sound harsh. This is a difficulty that I have noted in small rooms. However, I am not aware of any research into the acoustics of small rooms like this one. The large performance space has been studied a great deal (as it should be). A large part of the challenge in designing large performance spaces is to provide a sense of intimacy — to make the room act smaller, if you will. In smaller rooms, the task is reversed. How does one make the room act large enough for powerful performers? I have developed some approaches based on observation and experience, but research in this area would be helpful.

Another drawback to the room's design is the intrusion of noise from traffic. This was the price for natural light and a budget too constrained to pay for windows sufficiently robust to block outside noise. Although noise in a performance space is a blemish, I believe that transient noise is a lesser fault than the steady noise from mechanical ventilation. Because transient noise is transient: it goes away. Steady-state noise stays and creates a permanent mask over the performers' sound. Perhaps if we had anticipated that this room would be so heavily used as a performance space, we would have built smaller, more noise-resistant windows— or used glass block for natural light.

The Binns Room is in constant use as a venue for master classes, rehearsals, small recitals, and recording. So, a room that started out as a rehearsal space has become the de facto primary performance space. It is one factor in the continuing success of the Pennsylvania Academy of Music, a jewel in the cultural crown of southeastern Pennsylvania.

Acoustics of Two Unnamed Theatres

This was a difficult chapter to write because it is about failure. Failure is painful, but it is inevitable and perhaps necessary. The difficulty is compounded by the fact that public perception of acoustical quality is almost entirely a function of word of mouth. Spreading the word about the poor acoustics of a particular venue may do more than just hurt peoples' feelings; it could depress ticket sales. So, I endeavor in this chapter to obscure the identity of the spaces under discussion. Facts are altered to protect the innocent and the guilty. Hopefully the lack of detail will not detract from the lessons these two stories offer: lessons that are not taught in textbooks about acoustics.

Theatre A

Theater A was built in the 19th century with solid masonry construction and lots of architectural ornamentation, is of modest size (under 700 seats), and has four levels of seating. This makes for a very intimate audience chamber. The theatre was recently renovated, and it is just gorgeous. One look at the paint job will tell you that money was spent on this renovation, which included an additional new building and a sound system designed by a man who is a legend in the field. The sound system, incidentally, works just fine.

Unfortunately, listening to an orchestra perform in this theatre is disappointing. The sound is dull, monophonic. Solo instruments lack quality. There is no warmth, no envelopment. What is going on here? This is a small, masonry hall, with lots of architectural ornamentation to diffuse sound. It should sound rich and intimate.

Theatre A will perhaps never be *ideal* for orchestra because it doesn't have the volume to develop reverberation. Like the Academy of Music in Philadelphia (former home of the Philadelphia Orchestra), audience members entirely inhabit the audience chamber, leaving no volume without sound-absorbing surfaces. This theatre is a multipurpose lyric theatre. Many orchestras in the United States perform in multipurpose theatres rather than in dedicated concert halls. Is this a result of economics or merely tradition?

In a dedicated concert hall, the orchestra performs in the same room as the audience. In multi-purpose theatres, on the other hand, the orchestra often performs in a stagehouse, which functions as a separate room from the audience chamber. This room is lined with curtains, top and sides. Curtains absorb sound. The audience hears the orchestra through

the proscenium opening, which is surrounded by curtains as well. A stage shell may be utilized to reflect sound, with varying success.

Stage shells have acquired the mythical reputation of being able to "throw" sound out to the audience. They do no such thing. All they do is reflect *some* sound down into the orchestra and out into the audience that might have been lost in the cloth-filled stagehouse. I estimate that, ordinarily, when an orchestra plays in a proscenium stagehouse, more than half of its sound energy never makes it into the audience chamber. This percentage can be increased with careful design to overcome the inherent drawbacks of the proscenium stagehouse theatre, by using a massive, custom-designed stage shell. Sometimes, the stagehouse volume is used as a reverberation chamber as well.

The reverberant stagehouse approach was discovered by the esteemed acoustician Paul S. Veneklasen, who believed that reverberation from the stagehouse contributed to Carnegie Hall's acoustical quality. He later applied the concept to the Saratoga Performing Arts Center.[9] Examples of successful multipurpose theatres with stageshells for orchestral performance include the New Jersey Performing Arts Center in Newark, New Jersey; the Blumenthal in Charlotte, North Carolina; the Kravis Center in West Palm Beach, Florida; the Pikes Peak Centre in Colorado Springs; and Bass Hall in Fort Worth Texas.[10] The Theatre A renovation did not include a decent stage shell.

Notwithstanding, Theater A has many features that indicate decent acoustics. Why then are the acoustics so bad? A major part of the answer is background noise. At the last concert I attended, there was a steady whoosh of noise from the ventilation system that masked all acoustical virtues possessed by the theatre. There are two large air-handling machines located on a roof directly adjacent to the stagehouse. Why weren't these units located in the new building next door? I would guess that the client did not consider ventilation system noise worthy of notice.

Theater A does have reverberation (which is necessary for orchestral sound). All spaces have some reverberation. But any reverberation in this theatre is buried in the noise of the mechanical system. Silencing the mechanical system would reveal acoustics with warmth, intimacy, and clarity, acoustics perhaps lacking a bit in reverberation, but still very decent if not superb for orchestra. All that would have been required would have been setting aside enough in the budget to design and build a silent ventilation system.

The failure here results not from the abilities of the acoustical consultant for this project (a man for whom I have a great deal of respect) . The acoustics were surely decided by the client's priorities: paint is more important than sound.

Theatre B

I started hearing complaints about the acoustics of Theatre B—for which I had been the acoustical consultant—soon after it opened. This was particularly distressing to me because it was a project done early in my career, about which I cared a great deal. As is always the case, the problem started long before the opening, in the earliest stages of design, with the basic geometry of the room. Before having considered acoustics, the client became enamored of a shape that I immediately knew would cause acoustical difficulties: a hemi-sphere.

The client (actually a committee) was set on this shape. It was necessary, therefore, to come up with an approach that would, in essence, defeat the problematic geometry. I developed a design for a large, overhead sound-reflecting canopy. This is a time-honored approach with many successful examples, perhaps the best known being the Meyerson Symphony Center in Dallas, Texas. (See Figure 1, page 6)

The client decided to defer the construction and installation of the acoustical canopy–for aesthetic reasons. A canopy would obscure the sight of the lovely wooden ceiling. However, as I had predicted, acoustical difficulties arose. The center of the audience area was plagued with weird echoes.

Why a canopy? When a performer creates sound, some reaches the listener's ear directly; some arrives later after being reflected from the boundaries of the space. Sound reflections arriving at the listener's ear within 50 milliseconds of the direct sound are combined by our miraculous hearing system with the direct sound to increase strength and clarity. Later reflections contribute in other ways. But if these late reflections are too strong and focused, they can interfere with listening, especially with understanding speech.

Without the canopy, sound reflections in Theatre B arrive too late to support the direct sound. In addition, because of the problematic geometry, sound tends to continue circling around, returning to the audience late enough to make for an audible echo. It is nearly impossible to understand speech in some locations. An acoustical canopy reflects sound directly down to audience ears, reinforcing the direct sound. Since most of the sound striking the audience is absorbed, this reduces late reflections as well.

After a season of frustration with improvised measures to deal with the acoustical problem, one of the theatre's tenants hired a world-renowned acoustical consulting firm to study the problem. The firm sent a representative who took acoustical measurements and studied the problem. Their final report recommended—an acoustical canopy.

Two design firms given the same problem are likely to come up with solutions that vary somewhat. However, in this case, the consulting firm's solution closely resembled my approach — and it worked. The best, the most enlightened acoustical advice remains merely advice if it is not followed. For a period of time, I was considering changing the name of my firm from Orpheus to Cassandra.

As the next section will illustrate, this is neither the first nor the last time in history that acoustical advice was ignored.

Philharmonic Hall, New York

People who may know nothing else about acoustics know about the Philharmonic Hall debacle. I have often been asked, "If you acousticians know so much, why was Philharmonic Hall such a disaster?" The story would be a suitable subject for an entire book by a true investigative journalist. Although the history remains controversial, one point remains true: large halls pose large acoustical difficulties. The larger the seat count, the greater the difficulty in achieving excellent acoustics. And even a genius acoustician does not insure acoustical success if his advice is sufficiently diluted.

The Original Concept by Leo Beranek[11]

In 1956, Dr. Leo L. Beranek — perhaps the best known acoustician of his time — was hired as acoustician for the world's greatest concert hall to be built in Lincoln Center for the Performing Arts in New York City. Dr. Beranek's concept was based on his extensive study of 50 great concert halls, later published as *Music, Acoustics and Architecture* (1962, Wiley).[12] Beranek's initial approach was conservative, based on the classic shoebox form with narrow side balconies, common to all the best concert halls. Reverberation time was to be a generous 2.1 seconds with the hall fully occupied. A narrow stage and overhead sound-reflecting panels would provide early sound reflections for an intimate sound and to help the ensemble on stage. Lincoln Center accepted Beranek's approach, and the firm Harrison & Abramovitz was hired as architects. The seating was to be 2,400.

Unfortunately, Dr. Beranek's original concept was never realized. Over Beranek's objections, the seating was enlarged from 2,400 to 2,836 seats. Carnegie Hall, which seats 2,700, was not expected to escape the wrecker's ball.

The plan was altered from a rectangle to a sort of "Coke-bottle" shape in order to make room for the additional seating. The balcony fronts were altered to create convex forms. They plunged in such a way as to render them useless as sound reflectors for the audience. All sound-diffusing elements on the walls and balcony fronts were cut from the design just before construction,[13] making all surfaces perfectly smooth. There is some controversy over when and how Dr. Beranek discovered the alterations. In retrospect, perhaps he ought to have resigned on the spot. I for one, however, can empathize with the desire to stick with such a prestigious project and try to make it work somehow.

In addition to the deletions mentioned earlier, the number of overhead "acoustical clouds" was increased. The "clouds" in Beranek's design were originally intended to fly above the stage, but they were extended well into the hall. Beranek wanted to keep open the option of lowering or raising the panels with motors after the hall opened. Cost cutting limited this option as well.

The hall opened on September 23, 1962. Almost immediately, acoustical difficulties became apparent. The hall had a harsh, overly bright sound. There was a singular lack of warmth or bass. The orchestra members had difficulties hearing each other on stage. The sound was flat, without any sense of envelopment in the music for the audience. And there were echoes from a projection booth above the first balcony.

The concave shaping of the balcony fronts and the overall "coke-bottle" shape of the hall were responsible for the echoes. A team of scientists at Bell Laboratories figured out the reason for the lack of bass: the regular lattice of overhead reflectors was causing destructive interference, attenuating an important range of low frequency sound.[14] An alternative explanation is that the clouds were reflecting a disproportionate share of high-frequency sound reflections giving the subjective impression that there was a lack of low-frequency sound. This design gave "clouds" a bad name for the longest time, which is unfortunate, because clouds are a very useful item in the acoustician's toolbox. Other possible explanations for the lack of warmth include too much sound absorption from upholstered chairs, and a large metal grill around the stage that may have functioned as a narrow band low-frequency sound absorber.

The investigation into the defects of Philharmonic Hall brought to light a key concept in concert hall design. The lack of early sound reflections arriving at the listener from the sides, due to the smooth, plunging balconies, made for a flat, monophonic sound. It became apparent that "early lateral reflections" provided by features common in older halls, such as balcony undersides and ornamentation, were essential to the warm and

enveloping sound of these old halls. This concept has contributed greatly to the tremendous increase in quality in the post-Philharmonic Hall generation of concert halls.[15]

Intermediary Renovations

It is possible that Beranek could have alleviated some of these difficulties by rearranging the overhead panels (though the high seat count and the bulging geometry would remain). Beranek was, and still is, one of the most respected men in the field of acoustics. If anyone could have improved the situation, he could have.

Unfortunately, the great conductor George Szell took an instant dislike to the hall after a concert and convinced the Lincoln Center Board to engage a committee of acousticians to make recommendations for acoustical corrections. Beranek's subsequent recommendations were ignored. Over a period of six years, at a cost of almost $1.5 million, a series of substantial renovations was attempted. None was entirely satisfactory.

One fundamentally important aspect of Beranek's design was retained, however. Laymon Miller of Beranek's firm (BBN) designed the isolation from subway vibration, which included lead-asbestos pads inserted into the foundation piers. As a result of this and other measures, no environmental noise is audible in the hall, even though it sits in the middle of the busy Upper West Side of Manhattan, right above the noisy 7th Avenue IRT subway.

Cyril Harris and Avery Fisher[16]

In 1974, the Board of Lincoln Center approached Cyril Harris, a professor of architecture at Columbia University with several successful halls under his belt. A small sample of Harris's work includes the Kennedy Center in Washington, D.C.; the Krannert Center for the Performing Arts at the University of Illinois at Urbana-Champaign; the Minnesota Orchestra Association Orchestra Hall; Powell Symphony Hall in St. Louis; Abravanel Hall in Salt Lake City; and the recent Benaroya Concert Hall in Seattle, Washington.

Harris informed the board that in order to improve the hall they would have to demolish it and start from scratch. Money for this ambitious undertaking became available from the entrepreneur and music lover Avery Fisher, who contributed $10 million to the endeavor. Fisher had made his fortune in hi-fidelity and contributed a great deal of time and money to the performing arts.

Harris's new design was similar to Beranek's original concept in several important aspects: it was rectangular in form with narrow side balconies. Gone were the smooth, concave balcony fronts. The seat count was brought down to 2,742 (still high). A notable difference is the absence of overhead clouds. Harris does not believe in clouds, primarily based on the fact that their sound-reflecting capability is limited by their size. Or more correctly, their size places a lower limit on the frequency that they will reflect. Furthermore, none of the great 19th century concert halls has clouds.[17]

Harris's approach to acoustical design is based on these old, successful halls—the paradigms being the Concertgebouw in Amsterdam, the Muziekverreinssaal in Vienna, and Boston Symphony Hall. His halls are rectangular, with narrow side balconies, and with a prodigious amount of sound-diffusing surface irregularities of differing scale.

One example of Harris's work is next door to Avery Fisher Hall. The Metropolitan Opera House (built in 1966) seats 3,816, making it one of the very largest opera houses in the world.[18] For a hall this enormous to succeed acoustically is an astonishing feat. The Metropolitan Opera has never been altered. In spite of its enormous size (a voice of rare power is required to sing at the Met), I know of no serious criticism of its acoustics. It is known for its warmth of tone.

To achieve the required reverberation, all surfaces in Harris's concert halls are hard, massive, and dense — with one exception: the floors are designed to transmit vibration. Harris's theory is that one should feel the bass with one's feet. However, if low-frequency sound is moving the floor, then low-frequency sound is being absorbed; one of the persistent criticisms of Avery Fisher Hall is that it lacks warmth.[19]

Ventilation system noise control was constrained by the prohibitive expense of moving the original ventilation machinery.

Avery Fisher Hall was a distinct improvement over the original Philharmonic Hall, but musicians in the orchestra still had trouble hearing each other sufficiently for orchestral ensemble.

The Russell Johnson Stage Modification

This latest work in Avery Fisher was relatively minor, including only the stage. However, I was involved in the design and so can offer my personal perspective.

Kurt Masur, the new conductor of the Philharmonic, was particularly dissatisfied with ensemble conditions on stage. He had been "…forced to lead such a sensitive orchestra like a band leader, just to keep them together."[20] Masur began experimenting to try to improve matters. After

conducting the complete Beethoven symphonies at the City of Birmingham Symphony Hall, he decided to work with acoustician Russell Johnson, who had been the acoustical consultant for that hall. In November 1991, the Lincoln Center Board hired Johnson to develop a design to improve hearing conditions on stage for the musicians.[21]

I was working for Johnson in New York at the time. We began our study in February 1992. The first step was to review the literature on stage acoustics. The project also required interviewing the musicians, listening on stage during rehearsals, and attending concerts at Avery Fisher.

On 26 February, the stage was set as if for a rehearsal. Seventy assorted members of the New York Philharmonic staff (not musicians) were assembled on stage to sit in as bodies while we took acoustical measurements of the stage. We took readings that showed how sound was affected by the hall (including those bodies on stage) as it traveled from one musician to another. We then built a computer model of the stage to study the same sound paths that we had measured.

As we were studying the problem, Johnson began to generate approaches to the design of a set of stage reflectors. We studied the new design, as it was changing and developing, both in the computer and using a physical scale model, built of cardboard and foamcore. We hung clay and cardboard models of many versions of the new design. We studied the sound paths on the stage by shining a laser light to see how it would reflect off the various surfaces.

The design that finally emerged resembles two rows of tympani surrounding the stage, with two overhead reflectors. The tympani are riddled with bumps constructed of wooden dowels to diffuse high frequency sound. This acoustical concept was realized by John Burgee Architects. Burgee had been one of the architects for Avery Fisher Hall. He was chosen to ensure that the reflector design would blend aesthetically with the hall.

There was very little time to implement the design. It is enormously expensive to close down any performing venue, and the New York Philharmonic has a subscription concert series. It was built over the summer break in an amazing three and a half weeks between August 23 and September 14, 1992.[22]

The Results

Reactions from the musicians were overwhelmingly positive. A violist told me that the sound of the first violins (previously inaudible) "jumped out at her." Support from the reflectors helped the musicians play without forcing. Masur wrote to Johnson, "Your acoustical changes on the stage of Avery Fisher Hall in New York are really miraculous."[23]

The story of Philharmonic Hall/Avery Fisher Hall illustrates the extraordinary difficulty of designing a concert hall with a huge seat count; and the story also implies the converse: successful acoustics is much easier to achieve on a modest scale.

Leo L. Beranek, an Appreciation

Dr. Leo L. Beranek is one of the most admirable and influential figures in acoustics. The story of his work, his tremendous generosity, and his epic persistence are fascinating and inspiring. This section focuses on Beranek's contributions to architectural acoustics, which are considerable. For a broader view, see Janet Abbate's fascinating interview with Dr. Beranek in which he discusses his life.[24]

Dr. Beranek earned his undergraduate degree in physics and mathematics from Cornell College (Iowa) and his master's and doctorate from Harvard University. He has taught both at MIT and at Harvard, where he headed the Electro-Acoustics and Systems Research Laboratories.[25] As a teacher, Dr. Beranek is known to be supremely organized, inspiring, challenging, and able to explain difficult concepts to students at all levels.[26]

Beranek's teaching, however, extends far beyond the classroom. Through his prodigious output of books, scholarly articles and papers, he has been an inspiring teacher to everyone who has followed him. On a personal note, I was enticed into the field of architectural acoustics upon reading Dr. Beranek's classic text, *Music, Acoustics and Architecture*.[27] I know others who had a similar reaction to this book.

Leo Beranek, Richard Bolt and Robert Newman started the firm Bolt Beranek and Newman (BBN) in 1948 when the architectural firm Harrison and Abramowitz asked Bolt, who was at the time the director of MIT's acoustical laboratory, to help them with the acoustical design of the United Nations Headquarters in New York City.[28]

BBN went on to become the preeminent firm in the field of acoustics. Beginning with architectural acoustics, the firm branched into aircraft noise control, underwater acoustics, psychological acoustics, and the development of sound measurement instrumentation. In the 1950s BBN entered into the computer field and developed the first leg of the Internet, called the ARPANET. By 1977, when the firm merged with GTE, acoustics had become a relatively small part of BBN's work. The directory of the National Council of Acoustical Consultants is filled with firms whose heads started their careers working for Bolt Beranek and Newman.

Among BBN's many architectural projects was the successful

renovation of the Shed at Tanglewood, the summer home of the Boston Symphony Orchestra in the Berkshire Mountains in Lenox, Massachusetts. The Tanglewood Shed provides remarkably good acoustics for 5,000 people in a large, fan-shaped outdoor shell without any amplification.[29] The lawn directly in back of the Shed seats 10,000 people who listen via amplified sound. The re-built Shed opened in July 1959. It was the largest application of the suspended, acoustical-cloud concept at the time. It was a great success.

Based on the strength of their superlative reputation, BBN was hired to be the acoustical consultant for a new hall for the New York Philharmonic, Philharmonic Hall in New York (as discussed in the previous section). Heroic efforts went both into the design of the hall and into efforts to save the hall after nearly every one of Beranek's original recommendations had been ignored. The critics judged the hall harshly; Beranek's subsequent advice was disregarded, and (as far as the man in the street was concerned) blame for the hall's failure fell completely on his shoulders.

Aside from the cavalier attitude of the client towards Beranek's advice, the salient aspect of the Philharmonic Hall project was the prodigious amount of research and work that Beranek (and BBN) put into it. The acoustical concept for the hall grew out of Beranek's research, which was published in the aforementioned *Music, Acoustics & Architecture*. This study of fifty important concert and opera halls around the world covered over a decade's work. The preliminary studies for Philharmonic Hall itself took two years and included additional visits and measurements at world-renowned halls.

During the final stages of construction, Beranek and his colleagues took a week to perform a large battery of measuring and listening tests in the nearly completed hall. An artificial audience of fiberglass matts was installed in the seats to simulate the sound-absorbing qualities of an actual audience. The orchestra, under the direction of Leonard Bernstein, was engaged to rehearse and perform as the acoustical conditions in the hall were carefully adjusted.

When it became apparent that there were acoustical problems with the hall, Beranek went back to the labs at BBN and performed studies on the properties of sound-reflecting panels[30] and on the attenuation of sound across audiences.

This enormous research effort is typical of Beranek's approach. Also typical is his extraordinary generosity in publishing the copious amounts of information from measurements, informed with the insight he has gained from decades of careful listening.

After the Philharmonic Hall debacle, BBN continued to be active in

acoustical consulting. BBN's Theodore Schultz, for instance, was the acoustical consultant for such prestigious halls as the Roy Thompson Hall in Toronto, the Joseph Meyerhoff Symphony Hall in Baltimore, and the Scoring Stage at Skywalker Ranch. However, many people left BBN to form their own acoustical consulting firms. Although he continued to work at BBN for about eight years after Philharmonic Hall opened, Beranek did not work as an acoustical consultant for a major concert hall for nearly thirty years.

During this time, both Beranek and BBN prospered as BBN moved more and more into the computer business. Beranek continued doggedly to pursue his love of research, especially research into concert hall acoustics. Much of this research was funded out of his own pocket, and the results were summarized in two works. The first, "Concert hall acoustics—1992,"[31] is a thorough overview of the state of knowledge of concert hall acoustics up to that date. It contains a review of all the important research and thumbnail descriptions of important halls, including a terse description of Philharmonic Hall. The second is *Concert and Opera Halls, How They Sound*, to which I have referred many times.

In February of 1992, Beranek and William Cavanaugh founded the Concert Hall Research Group with a group of Acoustical Society of America members who are charged with the task of taking measurements in well-known concert halls the world over.[32] The goal of the project is to standardize procedures so that the different halls can be compared using the same types and methods of measurement.

In addition, Beranek has contributed to knowledge of the sound-absorbing properties of audience seating by taking measurements in new halls before and after the seating is installed. This data is difficult to acquire, since the window of opportunity for measurement is so small. I use these findings on a regular basis in my own work. Before Dr. Beranek made this knowledge available, at least three internationally known halls had run into acoustical difficulties due to underestimating the sound-absorbing properties of audience seating.

The year 1996 saw the long-awaited revised version of Beranek's classic *Music Acoustics and Architecture*. This completely rewritten version, entitled *Concert and Opera Halls: How They Sound*, is, as acoustician Lawrence Kirkegaard says on the cover, "— a rosetta stone for the languages of music, acoustics and architecture." This book is filled to the brim with useful information, measurements, photos, and a summary of the current knowledge of concert and opera hall acoustics. In addition to being a wonderful book for browsing, it is an indispensable tool for the professional.

After retiring from BBN, Beranek started commuting to Japan and began a new career as an independent acoustical consultant, collaborating with Takayuki Hidaka of the Takenaka Research and Development Institute. Out of this collaboration came the Hamarikyu Asahi Hall in Tokyo (1992), a hall for small orchestra, chamber music, recitals, and other small ensembles. It is a classic shoebox, with the stage in the same space as the audience, and with great attention given to the details of sound diffusion at a variety of levels.

This hall is Beranek's first after Philharmonic Hall. It was eminently sensible of Beranek to break ground with an intimate hall of proven shape. This hall is not intended to stretch the boundaries, but rather it is a careful design based on Beranek's extensive knowledge of what works in the design of halls for music.

On the other hand, Beranek's next major project, Tokyo Opera City (TOC), Tokyo, Japan, is a high profile, world-class cluster of halls. The opening was covered on the first page of the *New York Times* "Science" section, complete with a stunning color photo of the interior of the concert hall.[33] Situated on five acres in Tokyo, the Tokyo Opera City project contains a concert hall, an art museum, a 52-story office building, and an arcade of shops. The site is contiguous with the 6-acre New National Theater complex (NNT), which contains an opera house, a legitimate theater, an experimental theater, and numerous rehearsal rooms and educational facilities, as well as a sunken garden.

TAK Architects, Inc. won the design competition in 1985 for the New National Theater project (NNT). Sadahiro Masuda was acoustician for the competition. Takahiko Yanagisawa, the principal of TAK Architects, wrote that he was committed to "a more organic relationship among the specialist fields." It is clear from the opera house design that form really does follow function in this project. In other words, acoustics was integral to the design, and not something to be pasted on as an afterthought.

In April 1989, Beranek was chosen as acoustical design consultant for the NNT project, and in 1991 his commission was broadened to include the TOC project.

True to form, Beranek, with the collaboration of the Takenaka R&D Institute headed by Takayuki Hidaka, embarked on a seven-year-long research project into the acoustics of opera and concert halls. They began with a thorough review of the research literature (much of it written by Beranek himself). The design team visited great halls all over the world to listen and to take measurements. The staff at the Takenaka Institute built computer models and 1:10 scale wooden models. They took an extensive set of measurements in the models and compared these with measurements

taken in well-known halls. The papers that Beranek and his colleagues wrote to document the work on the TOC and NNT halls contain, among other things, interesting comparisons of impulse responses with existing halls, the completed halls, and the models.

Extensive laboratory testing was performed to determine the sound-absorbing properties of seats and to develop sound-diffusing shapes of a variety of scales that would integrate into the visual aesthetic of the halls.

The researchers felt that, compared with concert halls, there was not enough extant research on the unique acoustical demands of opera. So Beranek and Hidaka embarked on a study of 23 world-famous opera houses.[34] In particular, they were concerned with how the shape of the room can support the singing voice over the orchestra. They were also interested in designing provisions to adjust the acoustics in the pit.

Beranek discovered that singers welcome the sense of support that they receive from a slight, barely audible echo from the back of the hall. The exact amount of echo was too subtle to ascertain using models. So, after the NNT Opera Hall was built, the team embarked on experiments with singers to determine by trial and error just the right amount of sound-absorbing material to place on the rear wall of the hall.[35]

The opera hall and theatres were completed in 1997, eight months before opening.

The TOC Concert Hall is wonderfully audacious in appearance, reminiscent of some ancient ziggurat. The form is a rectangular volume topped by a distorted pyramid. Every square inch of interior surface appears to be covered with sound-diffusing shapes of varying scale.

The hall was first investigated with a computer model. After these initial studies, the investigators continued their analysis with 1:10 wooden models. By using miniature loudspeakers and microphones within models of human heads, and by scaling the using sound up by a factor of ten, they were able to study the acoustics of the hall both by mathematical analysis and by visual inspection of sound measurements taken in the model. Using these measurements, it is possible to synthesize and listen to the sound of the modeled hall.[36]

An overhead canopy was developed to provide support for the ensemble on stage and to provide more early sound reflections to the audience. The architect wanted the canopy to be as visually unobtrusive as possible, so the researchers used model tests to determine the smallest size canopy that would be acoustically effective.

As was done with the opera house, the data from extensive testing and adjustment in the completed concert hall were compared with results from the model tests.

Beranek states that it is "not necessary to duplicate previously successful halls precisely to achieve excellent results." However, despite its radical appearance, the TOC Concert Hall is a very conservative design from an acoustical point of view.

The plan is rectangular with side balconies, just like those paradigms of the nineteenth-century concert halls, the Musikvereinssaal in Vienna and Boston Symphony Hall. The TOC hall is relatively narrow, at 65 feet wide. (The Musikvereinssaal is roughly 63 feet in width and Boston Symphony Hall is 75 feet wide.) The TOC Concert Hall seats only 1,632 people. Although modern seating is more ample than in older halls, this seat count compares favorably with the 1,680 seated in the Musikvereinssaal. The original Philharmonic Hall in New York, on the other hand, was ballooned out to seat 2,646 within its 106-foot girth.

Mid-frequency reverberation is a comfortable 1.9 seconds occupied. To achieve this, seats were designed to minimize sound absorption and no carpet was placed on the floor. The stage is within the audience chamber, rather than set off in a separate room. The wooden stage floor acts as a radiator for the 'celli and basses. The stage walls fan out slightly as in Boston Symphony Hall.

The pyramid may appear radical, but it is completely covered with sound diffusing surfaces to avoid echoes. Sound-diffusing shapes cover the entire interior surface of the hall, including fine-scale shapes on side walls beneath balconies and large-scale shapes on balcony fronts and ceiling. As Beranek reiterates in everything he has written about concert hall acoustics, there is a direct correlation between the amount of sound-diffusing surfaces and acoustical quality.

An overhead canopy is not found in any of the classic nineteenth-century halls, and some well-known acousticians, such as Cyril Harris and Lawrence Kirkegaard, eschew this feature. However, the enormously successful halls of Russell Johnson[37] have demonstrated that the large overhead canopy is a reliable asset to the acoustics of a concert hall. In Tokyo, this break with the nineteenth century was necessitated by the pyramidal volume.

The TOC Concert Hall was completed in late fall 1996, nearly a year ahead of schedule.

Beranek continued his contribution to knowledge of the sound absorption of audience seating by measuring reverberation time before and after the TOC concert hall seating was installed. These sorts of measurements are critical for designers of all performance spaces in order to accurately calculate reverberation times for new spaces. The window of opportunity for taking these measurements is short. Beranek takes advantage of this window whenever he can and publishes the results.

Reactions to both halls have been overwhelmingly positive. The great 'cellist Yo Yo Ma, for example, opined that Beranek had performed a miracle.

In an article written in 1964 after the opening of Philharmonic Hall,[38] Beranek and several colleagues laid out the characteristics of good concert halls. It is interesting to compare Philharmonic Hall and the TOC Concert Hall relative to these requirements.

Table 4

Characteristics of good halls	Philharmonic Hall (as built)	TOC Concert Hall
Volume less than 663,000 cu. ft	Volume: 865,000 cu. ft.	Volume: 540,396 cu. ft.
RT-60 (mid-frequency) 1.8 to 2.1 sec. (occupied)	2.1 sec. (occupied)	1.95 sec. (occupied)
Rectangular plan	Rectangular, with concave balcony fronts, concave rear wall	Rectangular plan
Narrow, with average width: 72 ft.	Width: 106 ft.	Width: 65 ft.
Sound-diffusing surfaces and coffered ceilings	Quite plain, with almost no ornamentation to breakup or diffuse sound.	Extensive use of both large-scale and fine-scale sound diffusing surfaces of many types all over the hall
No echoes	Several minor echoes were discovered	All echoes covered by extensive diffusion

With the exception of reverberation time (RT), it is clear that Philharmonic Hall, as it was built, violated every one of the characteristics of the good halls highlighted by Beranek in his 1964 paper. The Tokyo Opera City Concert Hall rests comfortably within these parameters, which remain valid to this day.

5. Acoustical Excellence

A thing of beauty is a joy forever:
Its loveliness increases; it will never
Pass into nothingness;
— John Keats, from "Endymion"

Acoustics for What?

In order to discuss the acoustics of a space, it is necessary to have some idea of what function the room is intended to serve. Only then can one can decide what to do (or avoid) in order to design the room acoustically to serve that function.

What factors affect the acoustics of a space? In order of importance, they are as follows:

1. Size
2. Background noise
3. Geometry
4. Room surfaces.

In practice, this order is often reversed, with room surfaces taking top priority. It is convenient to alter room surfaces and difficult to alter something as fundamental as the size of a room or the location of noisy machinery. With some types of projects, modifying room surfaces may be enough, but for critical listening spaces, one must consider every factor.

There are several types of spaces which present the designer with differing acoustical requirements.

- Single-purpose performance spaces, such as lecture halls, drama theatres, synagogues, recital halls, and concert halls;

- Multipurpose performance spaces, including multipurpose auditoriums and churches;
- Rehearsal rooms, such as rooms for practicing music or drama;
- Noisy spaces, such as cafeterias, work spaces, gymnasiums, pools;
- Open plan offices;
- Meeting rooms, rooms for discussion and dialogue.

Single-Purpose Rooms

The single-purpose performance space is a delight. Spaces with a focused acoustical function, such as concert halls, recital halls, and dedicated lecture rooms, offer a real opportunity for a client with a limited budget to achieve acoustical excellence. Limit the size, exclude background noise, focus the design around acoustical function, and excellent acoustics comes well within reach. The most common difficulty with single-purpose spaces is scale. The large-scale concert hall, for instance, is a genuine challenge, with many failures and near misses to exemplify the difficulty of that challenge. On the other hand, modest-sized recital halls can work well, in spite of serious acoustical faults.

In real life, the true single-purpose performance space is rare. Nearly all performance spaces are multiuse in practice, if not by design. Even dedicated concert halls are used for a variety of purposes. Carnegie Hall, for example, has hosted events as varying as rock concerts, political meetings, jazz concerts, chamber music, orchestral concerts, and comedy routines.

Multipurpose Spaces

Multipurpose performance spaces are often built to save the money it would entail to build several dedicated spaces. A school, for instance, that might be better served by a music recital hall and a drama theatre, builds one large, multipurpose auditorium because of cost. Since they are built for reasons of economy, multipurpose spaces are often too large, with budgets too small to provide what is necessary to make them work. The large, multipurpose performance space is one of the most difficult acoustical challenges, even under the best of circumstances.

Making a multipurpose space work requires limiting size, complete elimination of background noise, appropriate and adjustable geometry, and adjustable reverberation. These are all big challenges that grow exponentially as the space gets bigger. There are some very successful multipurpose halls: the Kravis Center in West Palm Beach, Florida; the New

Jersey Performing Arts Center, in Newark, New Jersey; and the Cerritos Center for the Performing Arts in Cerritos, California, come to mind.

Churches offer an extreme example of the multipurpose space. Churches have several conflicting acoustical requirements during the same event. The acoustics during the service can't be altered to meet the acoustical requirements both for organ and choir on one hand, and speech intelligibility on the other. The differences are huge. Furthermore, there are severe aesthetic constraints on church design. For example, flying panels are an excellent tool for reconciling reverberation and clarity, yet church committees are reluctant to consider such visible measures. One example from my own practice, the Holy Spirit Church in Lancaster, Pennsylvania, successfully utilizes flying panels (sails) to provide clarity within a reverberant space.

Another excellent model for Protestant church design is the American Colonial Protestant church. These churches are modest in size, narrow, quiet, with side balconies. They work well for both speech and church music. Contemporary church design would benefit a great deal from careful study of these paradigms.

Rehearsal Rooms

Rehearsal rooms, unlike most performance spaces, are usually too *small*. For these rooms, one needs a combination of sound absorption and geometry that makes the room act like a larger room. Sufficient height is critical. Never the less, a music group that is too large or too loud can sometimes overwhelm the space. Sound-diffusing surfaces are necessary for this type of space as well. A rehearsal room that has sound-absorbing surfaces, but lacks sound-diffusing surfaces will sound dead and unresponsive and will pose difficulties in hearing amongst members of an ensemble.

Rehearsal rooms, often located near performance spaces or other rehearsal rooms, require good sound isolation from these other spaces. Although background noise may not be as critical in a rehearsal space as in a performance space, mechanical (HVAC) noise control can make all the difference in the acoustics. Relatively uncommon but very helpful is the use of adjustable acoustics for a rehearsal room utilized by different types of ensembles. A small vocal ensemble needs a room with some reverberation in order to blend its sound. A band, at the other extreme, requires maximum sound absorption. If both groups must share the same room, adjustable sound absorption is the means for satisfying both requirements.

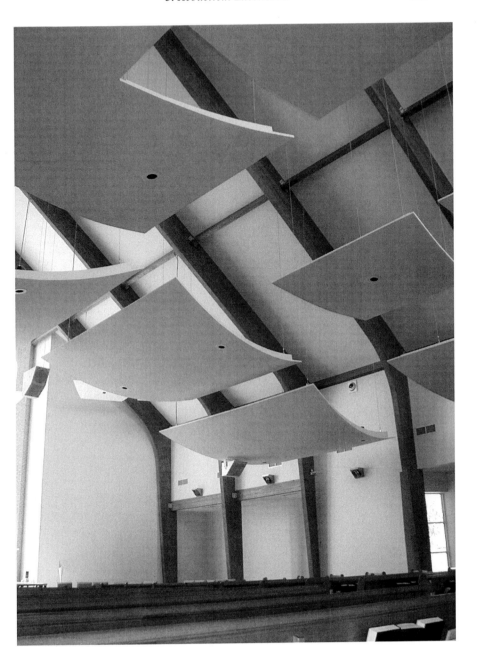

Figure 21. A church that utilized flying panels.

Noisy Spaces

Some spaces are not primarily designed with an acoustical function, but acoustics impedes other functions: these spaces are just too loud. The acoustical requirement for noisy spaces, such as cafeterias, work spaces, gymnasiums, and pools is straightforward: make them less noisy. There are two ways to accomplish this goal:

1. isolate the space from noise sources;
2. reduce reverberation.

It is always better, if possible, to control noise by removing a noise source. In the case of a cafeteria or gymnasium, however, the largest source of noise, people in the space, can't be removed. However, there may be other sources of noise that *can* be removed to make these spaces quieter, such as air-conditioning units and — very commonly — drink vending machines with loud, built-in refrigerators.

Changing room surfaces to reduce reverberation is often the *only* practical solution for quieting a noisy space. The basic problem is to determine how to get in as much sound-absorbing material as possible at a reasonable cost. Also, sound-absorbing material tends to be fragile, an important consideration for gymnasiums. As a rough rule of thumb, reverberation is proportional to height. A higher space will have an empty volume above people, where sound can bounce around, unimpeded by the sound-absorbing people below.

Open-Plan Offices

Open-plan offices are the exact opposite of concert halls. A concert hall is for enhancing soft sounds for concentrated listening at a distance. In an open-plan office, on the other hand, you don't want to hear a pin drop; you want to be able *not* to hear your colleague on the phone. This is achieved by acres of acoustical tile and intentional background noise. The background noise can be the HVAC system, or it can be intentionally installed electronically generated pink noise.

Meeting Rooms

Meeting rooms are rooms for discussion and dialogue; this includes classrooms. Size and background noise should be the first priority for designing these spaces. The number of people may necessitate a certain

size, but minimizing the size will almost always be acoustically beneficial. How much acoustical difficulty is encountered in an intimate living room? None. But meeting rooms that are larger than a living room require more care in their design. To optimize conversation among a large group of people, it is necessary to completely exclude background noise.

Acoustical design for meeting rooms rarely goes beyond the use of sound-absorbing materials to lower reverberation. This complete reversal of priorities is one reason for both the poor acoustical quality of the vast majority of meeting rooms, and the awkward over-reliance on sound systems for even modest-sized meeting rooms.

TELECONFERENCING

Teleconferencing rooms are an extension of the ordinary meeting room. These rooms can be used for ordinary meetings, but participants can be brought in from the outside electronically. This participation may be one way, in the form of an audio-visual presentation, or it may include dialogue with people whose physical location may be virtually anywhere. The acoustical requirements for these rooms are very stringent because the quality of the distant connection may vary, as anyone who has had a conversation involving a speakerphone is aware. The key is to create ideal conditions for speech *within* the room so that conditions within the room will interfere as little as possible with conditions *between* rooms. The three conditions for ideal speech intelligibility are:

- elimination of background noise;
- very low reverberation;
- diffuse sound reflections to support the speaking voice.

Good speech intelligibility results from sufficient speech level relative to background noise. It is *always* better to improve this relationship by lowering noise rather than by artificially increasing the level of the speaking voice. This is particularly true in rooms that are connected electronically to other rooms. The reason that you should avoid amplifying the speaking voice *within* the same room as the person talking, is illustrated by the hosts of talk-radio shows asking their callers to turn off their radios at home. This is to avoid distortion: coloration and feedback. It is true that software exists to filter out this effect, but it is always better to avoid creating noise than to first create noise then to filter it out after it has been created.

In every type of critical listening space, there is vast potential for improved acoustical quality to be had by merely by reducing noise. The question is: how good should it be?

How Good Should It Be?

As illustrated by the Philharmonic Hall saga, contracting the services of an acoustical consultant — even a superbly talented, genius acoustician — is no guarantee of acoustical excellence, or even of decent acoustics. Acousticians are not magicians; we merely offer advice. Ultimately, acoustical quality is determined by the will of the client.

The fee for acoustical consulting is a fraction of the costs involved in building a space with excellent acoustics. Excellent acoustics will entail construction and design costs and will profoundly affect other aspects of the building. For many projects, excellent acoustics may *not* be appropriate. Acoustics is, after all, only one item, and must be balanced with other aspects of the program.

If you are involved in the design of a space where listening is important, you must realize just how many things affect acoustical quality in order to make informed choices. If your project is reasonable in size (up to 1,000 people) and is intended to endure, I heartily encourage you to go for acoustical excellence. What, you may ask, does this require?

Excellence in Listening Spaces

First, the exclusion of all background noise is essential. Excluding background noise allows crystal clarity of sound, maximum dynamic range, enhancement of the performer's freedom of expression, intimacy between the performer and audience, and the ability to hear other more subtle acoustical virtues.

As I have discussed in the section entitled *Silence Is Golden*, the problem with background noise is *not* distraction. Because of our miraculous hearing system, we can ignore even very high levels of background noise. Background noise *masks*, or covers up, fainter sounds, thus limiting the dynamic range of a performer and interfering with clarity and understanding.

A space with audible background noise is just not acoustically excellent. I feel so strongly about this that even in very tight budget projects, I encourage the client to spend a large portion of the acoustics budget on noise control. In a modest-sized space, eliminating background noise brings the space a long way towards the goal of acoustical excellence.

Excluding background noise requires complete structural isolation of the critical listening space from all noise and vibration. This requires two separate structures in the building: a "noisy structure," where all noise sources are located; and a "quiet" structure, where the critical-listening

space is located. Buffer spaces, such as corridors, between the "noisy struc-
ture" and the "quiet structure" are necessary to protect the critical listening
space from noise. Buffer spaces and sufficiently massive wall and ceiling con-
structions are also necessary to protect the space from the outside world.

To avoid bringing noise into the space through the duct system, over-
sized, lined ducts, additional sound attenuating devices, and sufficient duct
distribution to avoid diffusers are required.

All of these measures require thinking about the locations of noisy
items from the very beginning of the design process. Furthermore, the
HVAC budget must be much larger than for a typical building, and wall
and roof constructions must be considerably heftier.

The client decides whether the benefit of excellent acoustics is worth
the price.

Size and the Triangle

Clearly, the level of acoustical quality strongly affects the cost of design
and construction of a project. How can an owner make sensible decisions
regarding cost and quality? Architects often use a visual device to illus-
trate the choices one must make in planning any building project.

SIZE

QUALITY BUDGET

Any two fixed vertices of this triangle determine the third. If you want
a building with a certain level of quality and it must be of a certain size,
you had better come up with the money to pay for it. Or, if your budget
is fixed and you must have a certain level of quality, then you have to be
flexible on size.

In most cases, unfortunately, the client initially determines a size; this
is engraved in stone. He later discovers (just before the project goes out to
bid) that his budget is limited. We all know what must happen to quality.

With critical-listening spaces there is a tremendous premium paid

for size. If you take a Wal-Mart or an office building and enlarge it, it just gets bigger. People don't seem to mind walking a little farther (indoors accompanied by Muzak®). But scale has a direct effect on the quality of a critical-listening space. A few dozen feet farther away from the vegetable aisle doesn't noticeably degrade the quality of a supermarket, but a few dozen feet farther away from Hamlet means you can't make out a word the poor Dane is saying.

When a critical-listening space expands, the requirement for low background noise becomes yet more stringent, mechanical systems become larger, and it becomes more difficult to balance the requirements for speech and music. So size increases cost *exponentially* in a critical-listening space. Very few owners are aware of the stiff price imposed by excess size. This is yet another reason to consider acoustics no later than the programming phase of design.

Acoustics, Aesthetics and Excellent Design

Because sound waves are large, anything designed to affect sound in a room — by absorption, reflection, or diffusion — must necessarily be large, and thus costly and visible. Large, costly and visible objects intended to affect sound grow in importance with the size of the room. A modest-size living room will probably be perfectly suitable with no attention at all paid to the acoustical design. But a large concert hall will be dominated by its acoustical design: the overall shape, the audience configuration, sound reflecting panels or canopies, special sound-diffusing surfaces, adjustable sound-absorbing curtains. All very large, very expensive, and very visible.

In large concert halls, the classic shoebox with one or more rows of balconies along the side walls has been a successful paradigm. Architects and acousticians have deviated from this paradigm at their peril. There are several examples of successful halls that don't *look* like shoeboxes, but they are designed to *act* like shoeboxes. An illuminating example is the Orange County Performing Arts Center in California. In plan, it looks like a fan, but it was designed by taking two shoeboxes and overlapping them. The TOC Concert Hall in Tokyo is another example of a hall that appears to have a radical shape, but is actually a shoebox in disguise.

There are a few examples of successful halls that break the rectangular mold, such as the Berlin Philharmonie Hall and the Christchurch (New Zealand) Town Hall. These halls are designed to provide a pattern of early, lateral sound reflections similar to that provided by the simple shoebox with balconies, but using more complex geometries.

Russell Johnson has successfully improved on the basic shoebox concept, adjusting the basic rectangle by squeezing it at the rear and undulating the walls. One might say that Johnson has been working on the same hall for fifty years, making steady, incremental improvements to the classic shoebox concert hall as he goes. Many features of the shoebox hall are retained in his design of the Dallas Symphony Hall — the first modern hall to take its place in the pantheon of great concert halls.

The most salient visual feature in the Dallas hall, however, is a departure from the nineteenth-century shoebox: the enormous canopy flying over the stage and part of the audience chamber. Sound-reflecting canopies or "clouds" were used extensively by Bolt Beranek and Newman and have become a tried and true method for dealing with the acoustics of larger rooms — the key to solving the classic problem of clarity within a reverberant space. To function properly, these flying clouds must be placed in highly visible locations and be large enough to reflect a sufficient amount and frequency-range of sound.

Another important constraint on architectural design is audience configuration. Safety codes, handicapped access, and liturgical issues compete with acoustics in the design of audience configuration. When a listening space reaches a certain size, above 500 people or so, it is imperative to stack the audience into balconies. In order to avoid placing people in bad seats under these balconies, the balconies need to be as narrow as possible. An excellent location for them is along the side walls. These side wall balconies provide several acoustical functions: they allow a more intimate audience configuration; their undersides reflect sound back down to audience ears below; and the balcony fronts provide an opportunity for sound-diffusing surfaces.

The lack of sound-diffusing surfaces was not a problem before the twentieth century, because extensive ornamentation was integral to the architectural vocabulary. With the International Style of Van der Rohe and Le Corbusier came the radical elimination of architectural ornamentation. This visual aesthetic created a profound conflict between visual and acoustical requirements in performance and listening spaces.

Acoustics lost this conflict when sound-diffusing ornamentation was eliminated from the balcony fronts of Philharmonic Hall. Architectural hostility to ornamentation has softened somewhat in recent years. But sound-diffusing surfaces in modern halls often look tacked on, forced. Architects are often reluctant to mess up nice, clean lines to sufficiently diffuse sound.

The last acoustical intrusion into the visual that I wish to discuss is adjustable reverberation. Adjustable reverberation is particularly important for large, multipurpose auditoriums, concert halls, and rehearsal halls,

since different performance types require different amounts of reverberation, sometimes *radically* different amounts. Furthermore, the number of people in a room may vary, and performers and audiences certainly vary in their taste for reverberation.

The best solution is to adjust reverberation by using sound-absorbing curtains. However, curtains are bulky, expensive, and awkward. Furthermore, in order to be effective, tremendous curtain surface area is necessary. I know of many rooms where the amount of curtain is not sufficient to make much of an audible difference. Architects tend to hate curtains because they are reminiscent of the décor reputed to be found in houses of ill repute; they are expensive; and they eat up space for travel and storage.

Architects prefer to hang permanent sound-absorbing panels for controlling reverberation. In a space where it is appropriate to lower reverberation and adjustment is not necessary, these panels can be a very useful tool, but as with all "acoustical" items, they have to be used appropriately. In multipurpose performance spaces, it is always better to change the reverberation of the room with adjustable curtains rather than using static sound-absorbing panels.

Another of Russell Johnson's extensions of the shoebox model is his use of reverberation chambers to broaden the range that reverberation can be adjusted. A wonderful example of this is the new Concert Hall in Lucerne, Switzerland.[1] In this hall, the audience chamber sits within a vast reverberation chamber to which acoustical access is controlled by enormous concrete doors. The reverberation chamber can become an enormous sound-absorber by filling up with curtains. This approach provides a wide range of reverberation from cathedral live down to nearly anechoic.

We acousticians love to aggrandize ourselves by emphasizing the extraordinary complexity of our arcane specialty. William J. Cavenaugh, a well-known acoustician, compares the difficulty of concert hall design with landing a man on the moon.[2] Surely, there is much to learn about concert hall design and architectural acoustics. As evidenced by a few spectacular failures (and many merely mediocre spaces) the design of large-scale concert halls is a difficult challenge. But with more modest projects, I believe that the difficulty lies not in the technical questions but rather in the practical, aesthetic, and financial conflicts that have to be reconciled.

Only the owner can decide just how acoustics fits into the big picture of a project. Excellent acoustics is not worth the sacrifice in every case. I often work with clients who must make the best of difficult choices. One of my purposes in writing this volume is to help readers who are planning to build to choose the appropriate level of acoustics for their projects.

Afterword

This book is based on my work as an acoustical consultant and musician with a passion for live performance in intimate spaces with wonderful acoustics. My experience as a professional violinist and as a lover of music brought me to acoustics. Working for Russell Johnson (the modern master of architectural acoustics) in his firm Artec Consultants, Inc. in New York gave me the opportunity to listen in some superb new halls (such as the Meyerson Symphony Center in Dallas, Texas) and to work on the design of some of the latest crop of truly great performance spaces (such as the New Jersey Performing Arts Center in Newark, New Jersey). Working on and listening in these spaces fed my passion for excellent acoustics. I was particularly struck by the astonishing clarity revealed by the extremely low background noise levels in these buildings: background noise levels at the threshold of hearing.

After three years of working in New York City (seeing my wife, Lynn, and son, Ethan, in Lancaster, Pennsylvania, only on weekends), I decided to start my own acoustical consulting firm, Orpheus Acoustics, in order to pursue the dream of acoustical excellence closer to home. My first project was to design a theatre for the Actors Company of Pennsylvania in the Lancaster Trust Building. Many people considered the acoustics of this building to be impossible for drama, but we did it; and we did it on a tight budget. The project was a great success largely because of the theatre's modest size, and the willingness of the client to make difficult choices in favor of acoustics: a paradigm for what I have advocated on these pages.

Notes

Preface

1. Statistical Abstract of the U.S. www.census.gov/statab/www (1996).

Introduction

1. Julianne Baird and Ron MacFarlane, *The English Lute Song*, Dorian Recordings—#90109/March 8, 1990.

Chapter 1

1. DE 3093.
2. DE 3103.
3. Every music lover ought to have a copy of Miles Davis' Kind of Blue, Sony/Columbia, ASIN: B000002ADT (originally on Columbia).
4. Joan Baez's unself-conscious recordings of these mini-operas are still fresh. Listen to Joan Baez Vol. 1 on Vanguard.

Chapter 2

1. L. Beranek and T. Hidaka, S. Masuda, "Acoustical design of the opera house of the New National Theatre, Tokyo, Japan," *The Journal Acoust. Soc. Amer.* 107 (1): 363 (2000).
2. Stanley A. Gelfand, *Hearing* (Marcel Dekker, 1990), 325.
3 Harvey Fletcher, *Speech and Hearing in Communication* (Acoustical Society of America, 1995), 188.
4. 1995 ASHRAE *Applications Handbook*, 43.5.
5. Calculated from William A. Yost and Mead C. Killian, "Hearing Thresh-

olds," *Encyclopedia of Acoustics*, ed. Malcom J. Crocker (John Wiley & Sons, Inc, 1997), 1549.

6. J.P. Newton and A.W. James, "Audience noise — how low can you get?" *Proceedings of the Institute of Acoustics*, Vol. 14, Part 2 (1992): 65–70.

7. "Occupational noise exposure," *Standards — 29 CFR* (OSHA) 1910.95: http://www.osha-slc.gov/OshStd_data/1910_0095.html.

8. Mike Bucsko, "Pennsylvania Man Kills Dirt Biker Over Noise," *Pittsburgh Post-Gazette*, September 8, 1997.

9. Here is the formula for adding 40 dB + 50 dB: $10^*(\log(10^{(40/10)} + 10^{(50/10)})$ ≈ 50.4.

10. Telephone conversation with Mark Ferroni, Pennsylvania Department of Transportation.

11. H.E.A.R. Website: http://www.hearnet.com.

12. "Title 15 environmental protection," *Anchorage municipal charter code and regulations, municipality of Anchorage, Alaska*, MA 2 (1997).

13. For sound levels in air, the reference is 20 µPa (20 micropascals), roughly the threshold of human hearing at 4,000 Hz.

14. Wallace Clement Sabine, *Collected Papers on Acoustics* (Harvard University Press, 1927, republished by Peninsula Publishing, 1992), 3–68.

15. Pink noise is sound with equal energy per octave band. It sounds like a waterfall.

16. John Tyndall, *The Science of Sound* (The Citadel Press, 1964).

17. Lothar Cremer and Helmut A. Müller, *Principles and Applications of Room Acoustics*, vol. 1 (Applied Science Publishers, Ltd., 1982), 174.

18. Edmund Scientific Web site: http://www.edmundoptics.com/IOD/DisplayProduct.cfm?productid=1655, 2001.

19. Dan Cruikshank, ed., *Sir Banister Fletcher's A History of Architecture*, 20th ed. (Architectural Press, 1996), 27, 831.

20. A pistol or handclap is not a perfect impulse but rather a good approximation.

21. J.P.A Lochner and J.F. Burgher, "The Influence of Reflections on Auditorium Acoustics," *J. Sound Vib.* 1(4): 426–454 (1964).

22. M. Kleiner, B.I. Dalenbäck, and P. Svensson, "Auralization — an overview," *J. Audio Eng. Soc.* 4 (11): 861–875 (1993).

23. Scott Russell, *B.A. Report* (1843) 96, cited in A.H. Davis, *The Acoustics of Buildings* (G. Bell and Sons, 1927), 56.

24. W.C. Sabine, *Collected Papers on Acoustics* (Harvard University Press, 1922, republished by Peninsula Publishing, 1992), 180–191.

25. R. Vermeulen and J. De Boer, *Philips Tech. Review* 1: 46 (1936).

26. F. Spandöck, "Akustische Modellversuche," *Annalen der Physik* 20: 345–60 (1934).

27. Michael Barron, "Auditorium Acoustics Modeling Now," *Applied Acoustics* 16: 279–290 (1983).

28. O. Yamamoto and O. Wakuri "Equipment and Acoustical Materials Used in 1:10 Scale Model Experiments," *NHK Laboratories note no. 77* (1968).

29. J.D. Polack, A.H. Marshall, and G. Dodd, "Digital evaluation of the acoustics of small models: The MIDAS package," *J. Acoust. Soc. Amer* 85 (1): 185–193 (1989).

30. Paul S. Veneklasen, "Model Techniques in Architectural Acoustics," *J. Acoust. Soc. Amer.* 47 (2) (part 1): 419 (1965).

31. Ning Xiang, *A Mobile Universal Measuring System for the Binaural Room-Acoustic* (Wirtschaftverlag NW, Bremerhaven, Germany, ISBN 3-89429-028-5 (1991).

32. M.R. Schroeder, B.S. Atal, and Carol Bird, "Digital computers in room acoustics," *Fourth International Congress on Acoustics, Copenhagen*, M21 (1962).

33. A. Krokstad, S. Strom, and S. Sorsdal, "Calculating the acoustical room response by the use of a ray tracing technique," *J. Sound Vib.* 8(1): 118–125 (1968).

34. L. Cremer and H. Müller, *Principles and Applications of Room Acoustics, vol. 1* (translated by T. Schultz, Applied Science, 1982), 25.

35. Peter Svensson, personal correspondence.

36. M.R. Schroeder, "S.5 Digital Simulation of Sound Transmission in Reverberant Spaces," *J. Acoust. Soc. Amer.* 47: 424–431 (1970).

37. B.M. Gibbs and D.K. Jones, "A simple image method for calculating the distribution of sound pressure levels within an enclosure," *Acustica* 26: 24–32 (1972).

38. J.B. Allen, D.A. Berkley, "Image method for efficiently simulating small-room acoustics," *J. Acoust. Soc. Amer.* 65: 943–50 (1979).

39. J. Borish, "Extension of the image model to arbitrary polyhedra," *J. Acoust. Soc. Amer.* 75(6): 1827–1836 (1984).

40. Heewon Lee and Byung-Ho Lee, "An Efficient Algorithm for the Image Model Technique," *Applied Acoustics* 24: 87–115 (1988).

41. J.P. Vian and D. Van Maercke, "Calculation of the Room impulse response using a ray-tracing method," *Proceedings of the Vancouver Symposium on Acoustics and Theatre Planning for the Performing Arts* (1986): 74–78.

42. M. Kleiner, E. Granier, B.I. Dalenbäck, and P. Svensson, "Coupling of low and high frequency models in auralization," *15th International Congress on Acoustics, Trondheim, Norway, 26–30 June 1995*, 533–536.

43. Rendell R. Torres, U.Peter Svensson, and Mendel Kleiner, "Computation of edge diffraction for more accurate room acoustics auralization," *J. Acoust. Soc. Amer.* 109(2): 600–610 (2001).

44. Robert A. Metkemeijer, "Proposal for a 'Round Robin' comparison of ray-tracing/image modeling programs," *International Symposium, Denmark, Sweden, Computer Modeling and Prediction of Objective and Subjective Properties of Sound Fields in Rooms*, 1991.

45. Michael Vorländer, "International round robin on room acoustical computer simulations," *15th International Congress on Acoustics, Trondheim, Norway*, 1995, 689–692.

46. I. Bork, "A comparison of room simulation software — the 2nd Round Robin on Room acoustical computer simulation," *Acustica/Acta Acustica* 86: 943–956 (2000).

47. Http://www.ptb.de/english/org/1/14/1401/hp.htm.

48. Peter Svensson, personal correspondence.

49. Mike Barron, personal correspondence.

50. Standing waves occur when the dimensions of a room allow a sound wave to double back on itself. This can cause the emphasis of certain frequencies, which can produce an unpleasant ringing sound.

51. D'Antonio, J. Donnert, and P. Kovitz, "DISC Project: Auralization using directional scattering coefficients," AES-Preprint no. 3727, presented at the 95th Conv., New York, 1993.

52. C.H. Haan, and F.R. Fricke, "Surface diffusivity as a measure of the acoustic quality of concert halls," *Proceedings of Conference of the Australia and New Zealand Architectural Science Association, Sydney* 1993, 81–90.

53. Leo Beranek, *Music, Acoustics & Architecture* (John Wiley & Sons, Inc, 1962).

54. Leo Beranek, *Concert and Opera Halls* (American Institute of Physics, 1996), 143.

55. Vitruvius, *The Ten Books of Architecture* (Dover, 1960), 143.

56. Lotar Cremer and Hemut Müller, *op. cit.*, 104.

57. Vitruvius, op.cit., 153.

58. Wallace Clement Sabine, *op. cit.*

59. Vitruvius, *op .cit.*, 153.

60. Allan Kozinn, "Concrete Culprit Unbared at Carnegie Hall," *New York Times*, Thursday, September 14, 1995: A1.

61. Michael Barron, *Auditorium Acoustics and Architectural Design* (E&F Spon, 1993), 34.

Chapter 3

1. Exodus (15:2) "— and I will glorify Him." The mizvot (commandments) should be practiced with grace and beauty.

2. Designed by S.Z Moslowitz of Wilkes Barre, PA, in 1963.

3. I measured 1.5 seconds reverberation time in the 500–1,000 Hz octave band, unoccupied.

4. Flutter echo occurs when sound can bounce back and forth between two sound-reflecting surfaces. It can be heard by clapping one's hands while standing in the right location.

5. The Acoustical Society of America has recently published a useful booklet on classroom acoustics. Copies can be acquired by contacting the Acoustical Society: phone: 516-576-2360, e-mail: asa@aip.org; Website: http://asa.aip.org.

Chapter 4

1. Their Web page is www.troymusichall.org.

2. Gemma Elise Champine, *Troy Music Hall — America's premier acoustical treasure*, UMI Dissertation Services, 1997.

3. For the program, see: http://www.crisny.org/not-for-profit/trychrom/ssns/98.htm.

4. Peter M. Senge, *The Fifth Discipline* (Doubleday, 1990).

5. National Park Service Web page: http://www.nps.gov/inde/congress-hall.html.

6. We kept the temperature comfortable by cooling the space before the performance. Weather cooperated.

7. Allen D. Pierce, *Acoustics, An Introduction to its Physical Principles and Applications* (Acoustical Society of America, 1989) 283.

8. Michael Forsythe, *Auditioria, designing for the Performing Arts*, (Van Nostrand Reinhold, 1987) 175–179.

9. J.P. Christoff, P.S. Veneklasen, and M. Mann, "Stage Auditorium Coupling for Variable Reverberation Time," *Acoust. Soc. Amer.* 37: 118(A) (1965).

10. Robert Long, personal correspondence.

11. Hans Fantel, "Back to Square One for Avery Fisher Hall," *High Fidelity Magazine*, October 1976.

12. A new, updated edition, *Concert and Opera Halls, How They Sound*, was published in 1996 by the Acoustical Society of America.

13. Leo Beranek, "Concert Hall Acoustics—1992," *J. Acoust. Soc. Amer*, 92: 12 (July 1992).

14. Yoichi Ando, *Concert Hall Acoustics* (Springer-Verlag, 1985).

15. For example, the Meyerson Symphony Center in Dallas.

16. Bruce Bliven, Jr., "Annals of Architecture, a better sound," *New Yorker Magazine*, November 8, 1976, 51–133.

17. Note that the most successful concert halls with clouds are Russell Johnson's (e.g. Dallas, Lucerne), with enormous and massive clouds (or canopies).

18. Leo Beranek, *Concert and Opera halls: How They Sound* (Acoustical Society of America, 1996), 135.

19. Allan Kozinn, "Acoustics at Avery Fisher," *New York Times*, November 16, 1991.

20. Allan Kozinn, *op. cit.*

21. Press release, Lincoln Center for the Performing Arts, Inc.

22. Allan Kozinn, "Fiddling With the Sound at Avery Fisher Hall," *New York Times*, Thursday, June 11, 1992.

23. Artec Consultants Inc. Website: http://www.artec-usa.com/What%20 They%20Said/Kurt%20Masur.html.

24. Janet Abbate, "Leo Beranek, Electrical Engineer, an oral history" (IEEE History Center, Rutgers University, New Brunswick, NJ, USA, 1996). It is available on the Web: http://www.ieee.org/organizations/history_center/oral_histories/ transcripts/beranek.html.

25. Leo L. Beranek, ed., *Noise and Vibration Control* (Institute of Noise Control Engineering), back cover (1971).

26. William J. Cavanaugh, Ira Dyer, "Citation for Leo L. Beranek, Honorary Fellowship in the Acoustical Society of America" (1994).

27. Leo L. Beranek, *Music, Acoustics & Architecture* (John Wiley & Sons, Inc., 1962).

28. William J. Cavanaugh, "20th century milestones in architectural acoustics," *NCAC Newsletter* Winter 2000, 4.

29. Leo L. Beranek, *Concert and Opera Halls*, 111.

30. Leo L. Beranek, F.R. Johnson, I. Dyer, and B.G. Watters, "Reflectivity of Panel Arrays in Concert Halls," SOUND —*Its Uses and Control* 2, No. 3: 26–30 (1963).

31. Leo L. Beranek, "Concert hall acoustics-1992," *J. Acoust. Soc. Amer*, 92 (1): 1–39 (1992).

32. Timothy J. Foulkes, personal correspondence.

33. James Glanz, "Art + Physics = Beautiful Music," *New York Times*, Tuesday, April 18, 2000, F1-4.

34. L. Beranek and T. Hidaka, "Objective and subjective evaluations of

twenty-three opera houses in Europe, Japan, and the Americas, " J. *Acoust. Soc. Amer*, 107 (1): 368–83 (2000).

35. Leo Beranek, T. Hidaka, S. Masuda, "Acoustical design of the opera house of the New National Theatre, Tokyo, Japan," *J. Acoust. Soc. Amer*, 107 (1): 355–67 (2000).

36. Leo Beranek, Takayuki Hidaka, S. Masuda, N. Nishihara, and T. Okano, "Acoustical design of the Tokyo Opera City (TOC) Concert Hall, Japan, *J. Acoust. Soc. Amer* 107 (1): 340–54 (2000).

37. The best known being the Meyerson Symphony Center in Dallas, Texas.

38. Leo L. Beranek, F.R. Johnson, Theodore J. Schultz, B. G. Watters, "Acoustics of Philharmonic Hall during its first season," *J. Acoust. Soc. Amer*. 36: 1247–1262 (1964).

Chapter 5

1. Architect, Jean Nouvel.

2. James Glanz, "Art + Physics = Beautiful Music," *New York Times*, Tuesday, April 18, 2000, F4

Annotated Bibliography

The following list includes what I would consider to be essential references in the areas of architectural and theoretical acoustics.

Architectural Acoustics

Barron, Michael. *Auditorium Acoustics and Architectural Design*. London: E&F Spon, 1993.
This book constitutes a thorough investigation of architectural acoustics, based around a study of British concert halls. Although the geographical location of the halls is somewhat limited, a wide range of types is studied, from drama theatres to opera houses to concert halls. Barron also illustrates his physical measurements in a consistent method that allows comparison amongst this wide range of halls. Barron has done an enormous amount of work with scale models. One photo shows him sitting inside a 1:10 scale model of the Barbican Concert Hall.

Beranek, Leo. *Concert and Opera Halls How They Sound*. Woodbury, New York: Acoustical Society of America, 1996.
This long-awaited second edition of the bible of architectural acoustics contains photographs and descriptions of important halls from all over the world.

Cremer, Lothar and Helmut Muller. *Principles and Applications of Room Acoustics*. Barking, England: Applied Science Publishers Ltd., 1982.
The mathematical level of this book goes up to partial differential equations, though there is much useful information below that level. The explanations are thorough and clear.

Egan, M. David. *Architectural Acoustics*. New York, NY: McGraw-Hill, 1988.
This book provides an excellent introduction and overview of architectural acoustics from the point of view of an architect. It has excellent illustrations, many useful tables, and little in the way of mathematics. It is the best book I know of as an introductory textbook and one I use often.

Sabine, Wallace Clement. *Collected Papers on Acoustics*. Los Altos, CA: Peninsula Publishing, 1992.

The first edition of the collected papers by "the man who started it all" was printed in 1922. Sabine discovered reverberation while working on acoustical problems in the lecture hall in the Fogg Art Museum at Harvard. In fact, the first unit of sound absorption was designated as one cushion from the Sanders Theatre across the street from the museum. It is particularly interesting to read how Sabine figured out how to investigate the nature of sound before microphones and electronics, using his ears and a set of organ pipes. Although Sabine is justly remembered for his work on reverberation, this book reveals the breadth and depth of his vision.

Theoretical Acoustics

Kinsler, Lawrence E., Austin R. Frey, Alan B. Coppens, and James V. Sanders. *Fundamentals of Acoustics*. New York: John Wiley & Son, 1982.
 This is the standard basic textbook on theoretical acoustics, and in addition includes treatments of architectural acoustics, hearing, and underwater acoustics. Mathematics goes up to partial differential equations. This book should be a snap to an electrical engineering student. There is some discussion of applications in regard to hearing, room acoustics, and underwater acoustics, and other topics.

Morse, Philip M. *Vibration and Sound*. Woodbury, NY: American Institute of Physics Acoustical Society, 1936.
 This book is a thorough treatment of the basic physics of sound and vibration. The whole first part of the book treats vibration of strings, bars, and plates before moving onto sound in air. There is no discussion of applications.

Pierce, Allan D. Acoustics, *An introduction to its physical principles and applications*. Woodbury, NY: American Institute of Physics Acoustical Society, 1981.
 This book is as mathematical as the Morse textbook, but ranges farther and is very thorough and rigorous. There is some treatment of room acoustics.

Sound System Design

Davis, Don and Carolyn Davis. *Sound System Engineering*. Boston, MA: Focal Press, 1997.
 This book is the bible of sound system design. Clear, well illustrated, and enormously practical. Anyone who has anything to do with sound systems has a copy.

 Http://www.SynAudCon.com/. Anyone who is interested in sound system design should join Synergetic Audio Concepts (SynAudCon). This wonderful organization, founded by Don and Carolyn Davis and now run by Pat and Brenda Brown, is the center for thinking on practical acoustics and sound system measurement and design. Synergetic Audio Concepts, Inc, 8780 Rufing Rd., Greenville IN 47124, phone: 800-796-2831, e-mail: brenda@synaudcon.com.

Index